Try Anarchism for Life

The Beauty of Our Circle

CINDY BARUKH MILSTEIN

Try Anarchism for Life is part manifesto, part prayer, part devotional—a rousing collection of vignettes and micro essays that inspire and incite. Read it to be warmed, guided, and changed. Accompanied by a wildly diverse set of illustrations of the anarchist logo, each essay offers a thoughtful meditation on how to do and think about anarchism in our world today. Full of love for the possibilities of the world to come. *Try Anarchism for Life* is a refreshing and necessary addition to the repertoire of anarchist literature.

—Rivers Solomon,
author of *An Unkindness of Ghosts*

Cindy Milstein teams up with some of the best and most active current anarchist artists to give us this collection of artful circle As, each accompanied by a textual meditation on anarchism and struggle that ranges from beautiful to cute to didactic to inspiring, and always with a core of wisdom. Milstein has a special touch.

—Peter Gelderloos,
author of *The Solutions Are Already Here*

Freedom struggles produce care, love, art. These things in turn demand courage, transformation, consciousness, ideals, dreams. Above all, struggle. Struggle gives birth to autonomy. And autonomy enables life. This book affectionately defends these things, and all the other things that state, capitalism, and patriarchy systematically steal from individuals, communities, and society. It invites people to see the world of anarchism as an ethical, beautiful way of living. Anarchism not as a rigid, static identity or form. Rather, *anarchisting* as a quest for creativity against dogma, solidarity against hierarchy, justice against power. A beautiful piece of work, a companion for the many collective journeys for meaning and liberation beyond borders.

—Dilar Dirik,
author of *The Kurdish Women's Movement:
History, Theory, Practice*

Try Anarchism for Life is both a beautiful homage to the countless fragments of ephemeral resistance that constitute everyday antiauthoritarianism and a principled call to commit to stitching together those fragments of daily autonomy-making into flourishing lives of resistance. Paired with unique renditions of the classic circle A, Milstein's poetic phrases endow age-old concepts like mutual aid and solidarity with renewed vitality and urgency.

—Mark Bray,
author of *Antifa*, *The Anarchist Inquisition*,
and *Translating Anarchy*

What a beautiful and playful collection of anarchist ruminations, like an imaginative picture book for adults (but not in the grown-up sense)! It's a joyful contribution to anarchist literature as well as to Milstein's own writing. You can read this poetic book in any order—an alphabet that goes from big *A* to little *a* and beyond—which makes it a perfect book to pick up to stimulate creativity and meditation. But after reading the whole thing, one gets the sense of the fullness of a life devoted to anarchism; that is, the mutual care and love for each other and the world that raises the stakes for freedom from domination. As we Jews say, "To life!"—that is, to a life worth living!

—Scott Branson,
author of *Practical Anarchism:
A Guide for Daily Life*

Try Anarchism for Life puts beauty back at the heart of the "beautiful idea." It is a gentle, warm reminder of the dreams that anarchism inspires and sustains. Utopian in the best sense of the word, it radiates hope and confidence, opens new vistas on familiar ideas, and affirms the value of mutual aid, solidarity, and creative collective endeavors.

—Ruth Kinna,
author of *The Government of No One:
The Theory and Practice of Anarchism*

Try Anarchism for Life: The Beauty of Our Circle
by Cindy Barukh Milstein
All prose and artwork © 2022 by their respective artists
This edition © 2022 Strangers in a Tangled Wilderness
ISBN: 978-1-958911-00-6
EBOOK ISBN: 978-1-958911-01-3

Strangers in a Tangled Wilderness
www.tangledwilderness.org

Cover design: Crisis, bycrisis.com
Cover art: Landon Sheely, linktr.ee/landonsheely
Interior design: Casandra, House of Hands, www.houseofhands.net

All proceeds from this book are gladly donated to
Strangers in a Tangled Wilderness to support its publishing projects.

To all who remained anarchists to their last breath,
and to all anarchists who aspire to do the same,
as keepers of the beautiful idea.

CONTENTS

Prologue: Try Anarchism for Life 4

1 | With Eyes Wide Open 13

2 | Collaborating for Freedom 17

3 | Reaching for the Stars 21

4 | Only a Beginning 25

5 | Ecotones of Possibility 29

6 | Art of Resistance 33

7 | Self-Propagating Roots 37

8 | Imperfectly Perfect Selves 41

9 | Rebellious Honoring 45

10 | Sticking Side by Side 49

11 | Bonds of Trust 53

12 | Sweetness of Borrowing 57

13 | Umbrellas of Protection 61

14 | Soaring Ever Higher 65

15 | Deciding for Ourselves 69

16 | Seriously Playful 73

17 | Commons of Care 77

18 | Ecological Toolbox 81

19 | Most Delicious of Flavors 85

20 | From the Ground Up .89

21 | Food Is Life .93

22 | Dangerous Together .97

23 | Love Is Freeing . 101

24 | Beautifully Simple .105

Epilogue: The Beauty of Our Circle .109

About the Author .111

Strangers in a Tangled Wilderness . 113

Circle A by Erik Ruin

Anarchism is a utopian horizon by which to orient oneself, a lens through which to look for all the hierarchies we will need to dismantle, an incomplete map.

Erik Ruin is a Michigan-raised, Philadelphia-based printmaker, shadow puppeteer, and paper cut artist who has been lauded by the *New York Times* for his "spell-binding cut-paper animations." His work oscillates between the poles of apocalyptic anxieties and utopian yearnings, with an emphasis on empathy, transcendence, and obsessive detail. He is a founding member of the Justseeds Artists' Cooperative.

PROLOGUE: TRY ANARCHISM FOR LIFE

This book started as a walk.

In hindsight that seems fitting. As you'll find when you wander through these pages with me, anarchism is a journey. It is the process of continually striving toward that place called *freedom*, vigilantly yet valiantly, by acting as if we're already there, and perpetually widening our understandings of what that "destination" could and should look like. Which is to say, it's a hard road that demands much of us, and always will. What too often gets lost, though, is the abundance of beauty along the way. We make countless paths toward utopia not by reaching some illusory end point where all is static perfection. Rather, "anarchism" is what happens when we steadfastly venture forth, accompanying each other side by side with collective care through perils and potholes as well as stunning vistas and way stations of possibilities.

That means trying anarchism for life.

Anarchism, of course, has as many poetic definitions as there are anarchists, which in itself gets at some of its expansive description. For anarchism's fundamental antagonism to all forms of *power over*, even the power over circumscribing the term, and exuberant openness to self-determination mean that the word must stay dynamic, able to flexibly embrace all sorts of liberatory ethics and practices. It can no more be contained than can all the innumerable ways that humans and the nonhuman world engage routinely in forms of mutual aid to not only survive but also thrive. Anarchism is a persistent yearning for and rebellious unfolding toward forms of freedom, which will always be (you guessed it) a journey.

So what *Try Anarchism for Life* revolves around is, in essence, a thought experiment: What are some of the many beautiful dimensions of anarchism?

In response, this book plays on the double meaning bundled in *for life*. My not-so-secret agenda here is equally double-edged. I want to heartily encourage you, dear reader, to become and then stay an anarchist for the rest of your life, warmly stretching out your hands to generations of rebels past and future. At the same time, I want you to do so in service of—and with love for—dignified, bountiful, and livable lives for all, in stark contrast to the cold and calculating death machines we're up against on a daily basis.

Indeed, I'd assert that being *for life* is a sacred obligation if we take seriously the inherent worth of all beings, our shared ecosystems, and this planet, our one and only home. Being *for life* binds us to do good for and with each other by humbly yet doggedly aspiring toward and cultivating ever-greater forms of wholeness, of messy beauty, in the here and now. Hence the emphasis on *try*, meaning imaginative experimentation; meaning to strive for wins such as upsurges of social solidarity, time-spaces of self-governance, and all other ephemeral yet joyous moments of everyday anarchism; meaning always, as both duty and pleasure, as (and for) life, to try, try, try again.

But I've strayed a bit from the walk that led me to this book.

For those of you who "follow" my frequent dérives via my Instagrammed picture-prose of what I see, this isn't a surprise. I stroll not to get to the "somewhere" of, say, capitalism or the state. I ramble at cross-purposes with the world *as it is*, thereby freeing up my mind and heart to notice all the "cracks in the pavement" and what's already blossoming in them. That, in turn, is generative of all sorts of flights of fancy about the world *that could be*, particularly if we build on actually existing forms of anarchistic praxis. Many times—thanks perhaps to some of you, my good troublemaking readers—I stumble on and take photos of street art, and then borrow that image as muse for the words in my posts.

One fine day, on one fine aimless walk, I saw my umpteenth circle A spray painted across a wall. Like pretty much all the others, it looked hastily done, with little eye for aesthetics. I snapped a photo, because no matter how scrappily scrawled, seeing a circle A feels like running into an old friend.

Yet for some reason, this time it got me thinking about why I'd rarely, if ever, seen a *beautiful* circle A tagged illicitly across the stolen landscape. Nor for that matter, why I'd rarely seen any street art that portrays the kinds of beautiful social relations and social organization anarchism actually conceives of and/or already models. "All cops are bad," yes, but what tangibly makes for "autonomous communities are beautiful"? Why is it so difficult for anarchists to depict what we are *for*, what we *desire*, and in ways that resonate, visually and verbally, with people who see a circle A sticker on a lamp post or stencil on a sidewalk, and either have no idea what it means or only pejorative caricatures in their head?

And so began the second step of this book's travels. That evening's picture-prose on my Instagram offered up a game, or what might better be labeled a friendly anarchist challenge. I asked folks to illustrate the beauty of what anarchism means to them by weaving their vision directly into a circle A, then sharing the artwork with me, and I'd then share it on my social media. Slowly but surely—and eagerly—anarchists sent me their creations. But many of them got stuck on sketching what we're against, with drawings of things being smashed, set on fire, or otherwise turned to rubble. I marveled again at how tough it is, even for us anarchists who can imagine worlds without police or prisons, communities without colonialism or commodification, to artfully and accessibly express our aspirations.

This tendency to lean into critique is partly a product of this era in which so many horizons have shrunk or disappeared, including that of a future—at least for us human beings. "Apocalypse" is far more imaginable now than the "other possible worlds" proclaimed by movements a mere twenty years ago, with each morning bringing fresh new disasters and more to rage against. We are keenly aware of the toll that these myriad catastrophes take and at whose doorstep the systemic fault lies, yet in a time when fascistic inclinations have more attraction and influence than anarchist ones, all that gets largely erased by conspiracy theories and false news.

It's no wonder, then, that we feel an extra sense of responsibility to point out all that's so deeply, horribly, murderously wrong; we are reel-

ing from the collective traumas and immense losses ripping the globe apart. Sadly, that's pushed anarchism into a more reactive corner, or almost a standstill, where we seem to invisibilize our greatest strength: all the proactive ways that we already shape and participate in life-giving alternatives. Meanwhile, those on the Far Right have been busily shaping and participating in their own "alternatives," especially by providing people with tangible communities of care, albeit ones that "care" for select few types of bodies and hate all of ours to a genocidal degree.

What these white Christian patriarchal supremacists and their allies know—and we anarchists seem to have forgotten—is that supplying what people need and desire, or at least telling them powerful stories about being able to do that, actually does draw folks to your side. And fascistic forces are, in particular, exceptionally good storytellers and propagandists, even if their tales repel us. They understand the power of symbols to win hearts and minds, and in their case, foot soldiers. For people won't give up what they have, even if it's miserable, unless they are moved by narratives that make them think it's worth the gamble.

Why is it so hard for us to paint gorgeous pictures of anarchism? To show glimpses, vibrant and varied, of the many ways we create spaces in which people feel more alive and whole than ever before? Do we think it's somehow self-evident, without having to actually make it clear that such do-it-ourselves beauty takes voluntary "work"? Even if, or particularly if, there truly is no future for our species, we anarchists are busy making whatever time we have left as good as possible, and for as many as possible. So why do we find it so difficult to portray this to others? Do we not have enough faith or trust in our own visions, or what we put into motion? Are we too weary and dispirited? Too cool or too scared? Do we take security culture too far, masking all the good we do? Is it a lack of ingenuity, or because we're also so broken by the social order that we can't think outside its box?

Why, by and large, have we anarchists lost the art of storytelling?

Our anarchist ancestors, or at least far more of them, used to be so much better at finding a balance between the urge to critique and destroy *and* the urge to be visionary and create, which I'd contend is what most makes anarchism so otherworldly marvelous. They conjured up

fantastic panoramas of potentialities, lavishly articulated in everything from their manifestos, artworks, books, newspapers, and soap box speeches, to theatrical productions, dances and music, humor, inventive ways of living, and celebratory gatherings, among many other examples. They captured the popular imagination and sparked larger, bolder, more solidaristic movements by freely handing people a compass. They aided them in discovering not merely the absences, whether of states or bosses, but also the presence of already-existent lifeways that they believed could take the place of hierarchy and domination, even when they felt disillusioned or exhausted, frightened or hurt.

When I walk, I imagine that they are walking alongside me in their well-worn shoes.

Ah, but I've taken a detour again. Let me circle back to my Instagram prompt.

Like all good cooperative games, I took myself up on my own challenge. I decided to stroll off social media and jump headlong into this book-as-journey, pushing anarchic artists and myself to unequivocally illuminate that anarchism is in fact remarkably beautiful. First I put out a "call" for artwork and was overwhelmed with the number that I received—all of them fabulous. Still, I had to narrow down the amount to make for a doable book, and in part, picked ones that felt like they'd be good muses for what I wanted to say in these essays. While I definitely riffed off the circle As, I realized that ultimately all the words and ideas would be my own, so I asked each artsy anarchist to give me one sentence about the impulse behind their creation; you'll find those, with short bios for each person, below their piece.

As with most of my meanderings, especially during an interminable pandemic, the route became ever more circuitous and rocky, and I wasn't sure I could finish this project. But a strange thing happened along the way: the more I immersed myself in trying to craft the prose herein, the more I stopped seeing the present only in the negative. I was able to see anew our contemporary anarchistic successes, if indeed *life* is our measure. For a funny thing occurs when we nudge ourselves to spell out the goodness within anarchism: we can't help but be revived and, dare I say, believe in our collective selves. It's no exaggeration to say

that in this time of widespread abandonment, we anarchists refuse to leave people's sides. We leap into the fray armed with a diversity of tactics and self-organized first-aid kits overflowing with communal care, mutual aid, and fierce love to tend to any and all wounded by this world, including each other and the earth. Time and again we demonstrate through our actions, large and small, that all is not lost, that whole other ways of being and living are already here.

The book you now hold in your hands is intended to inspire and delight you, my companionable readers, with picture-prose ranging from the playful and sweet to the magical realist and dreamy transportive. It aims to encourage those of us who are anarchists to notice and expand on our prefigurative practices, especially against the backdrop of a period when so much feels impossible. Yet it's also geared to be fun, friendly, and inviting for your biological as well as chosen families and friends who don't quite get (yet) why you are an anarchist, or those many people who are curious about or new to anarchism, or all those many others who are already "doing anarchism" without knowing there's a name for it. And it's meant to counter the too-enduring allure of authoritarian communist, social democratic, and liberal sensibilities with the appeal and relevance of anarchism. Mostly it's a gift to, I hope, warm your ailing heart and offer tender succor, with my love.

Try Anarchism for Life is, however, a never-ending effort. I encourage you to continue the "game" long after you've ambled through the pages of this book. Make enlarged photocopies of your favorite circle As here, for instance, and cut stencils from them in order to redecorate your city. Better yet, create your own beautiful circle As and put them to good use, whether to bedeck T-shirts or bedazzle walls. Or apply your anarchist art—from the arts of printing and writing, to those of educating, agitating, and organizing—to putting the beauty of anarchism into the world for all to see, even and especially amid all the loss, trauma, and sorrow of these days.

It's up to us, with like-minded heretics, misfits, and other queerly beautiful accomplices, to realize the impossibly beautiful that's smack dab in the middle of the many paths that we're traversing together now.

For if we don't keep the beautiful ideas of liberation and freedom alive, who will?

Unbounded and abiding gratitude to each and every one of the artistic anarchists who contributed to this book with their big hearts and enchantingly evocative circle As; the Strangers in a Tangled Wilderness collective members—Brooke, Casandra, Inmn, Margaret, Io, and Robin—as well as my beloved friend Jeff Clark of Crisis studio for embodying the best of anarchism to its fullest and being a dream team to collaborate with, further drawing out the beauty of this project; Julián González Beltrez and Eager Nil for enthusiastically and ably volunteering to proofread the laid-out pages; my not-anarchist but anarchistic chosen sister for believing in me and this book when I most needed it; my beloved friend paparouna for the ecotone insight, just a sliver of the wisdom they share in abundance, and for always being there for and with me through the ecotones of life; and all the many, mostly queer, trans, Jewish, and/or feminist anarchist friends, families, and communities—not to mention both my chosen sisters—for supplying so much reciprocal care during the many excruciating moments of these pandemic years (I wouldn't have made it through without you), thereby also gifting me with so much sweet "material" for *Try Anarchism for Life*.

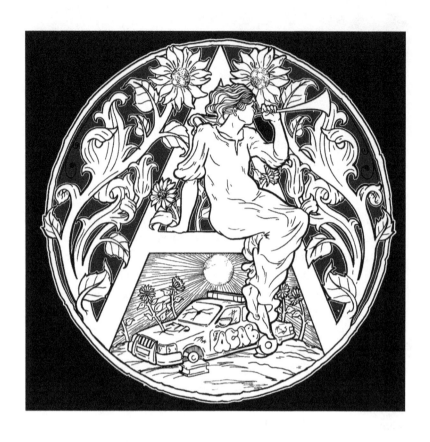

Circle A by N.O. Bonzo

The word that resonated when making this circle A was herald.

N.O. Bonzo is an anarchist illustrator, printmaker, and muralist based out of Portland, Oregon. They are the illustrator of *Mutual Aid: An Illuminated Factor of Evolution* (PM Press, 2021). More of their work can be found at www.nobonzo.com.

1 | WITH EYES WIDE OPEN

Images of us reveling in the ruins are like a Rorschach test.

With eyes aimed squarely at the disaster—whether the disaster of colonialism or capitalism, to offer only two names—we see nothing but destruction. We perceive only the horrors underfoot, as embodied in the charred corpse of a cop car, the carnage of riots and uprisings. We visualize a totality of enemies, piled high in fiery negation, with other enemies still lurking dangerously in the periphery. With these eyes, so myopic, we see like a state, through the bars of a carceral logic, guarding ourselves from ever escaping the cage of disastrous ways of thinking and acting and living.

With eyes opened wide by anarchist spectacles—by both ethical "eyeglasses" that expand our horizons and eye-catching public displays of our collective strength—we see everything that's possible. We notice the beauty swirling around us, as embodied in thousands of strangers turned into friends, the elixir of rebellious dates and times. We recognize that vehicles are simply objects that can be repurposed momentarily, transformed into makeshift dance floors, overflowing with people improvising their own music together, beckoning in the world to come. With these eyes, so hyperopic, we see like an autonomous community, through our own power-from-below, freeing up what's realizable, as if it were already here.

With eyes that are clear, we see destruction and creation as forever intertwined, twirling atop cop cars with us. We glimpse potential because we don't look away from all the suffering that shouldn't be happening, all the harm that could be avoided. We read the world through these contrasts, a great chasm of *what is* and *what could be*, made all that much more poignant, all that much more imperative, because we know that the solidarity we get to enact and relish in during riots and uprisings comes at the always-too-high cost of another murder-by-police, like some clarion call urging us into the streets.

Or maybe, with eyes that see in ways we can hardly begin to imagine—like in that sweet spot each day at twilight when the sun and moon feel as if they pass each other as comrades, and light refracts to illuminate colors that aren't accessible at any other moment—cop cars can be stripped bare of all prior mystique and meaning. They can be refashioned into carriers of our dreams, whether public transport, or really really free rideshares, or an end to car culture altogether, their metal cobbled into sculptures or cozy little houses. Maybe with these eyes, tender and willing to make and hold direct contact with each other, the ruins will someday appear only as museums to all that didn't serve us and this imperiled earth. Or as playgrounds where we scramble across the broken pieces with delight, hardly even knowing why they held such sway. Or as archaeological sites where those who love to sift through the sands of the past—with the express consent of those who see these lands as sacred—will uncover artifacts that appear wholly strange and unintelligible and useless.

What do you see? Or what do you want to see?

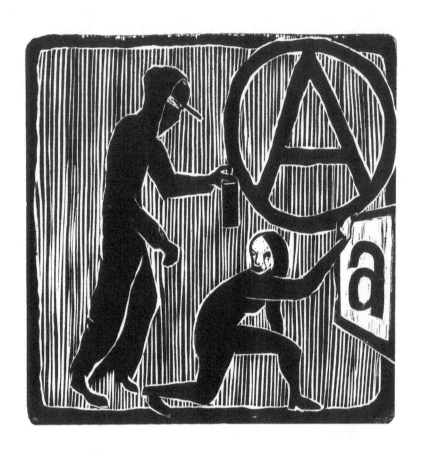

Circle A by Squat Taco

Keep art to a minimum, roll with a friend, use multiple craft, aerosol, and paste!

Squat Taco and friends have been putting up posters around the Pacific Northwest with staples and wheat paste for seven years now, trying to be vandals and propagate the tenets of anarchism.

2 | COLLABORATING FOR FREEDOM

There are those who've written about the "ABCs of anarchism," yet we hardly need to wander much past the letter *A* in order to spell out what's bundled agreeably within the circle A. *Antiauthoritarian*—and so many other antis like *antistate* and *anticolonial*—and *agitation*. But equally and more proactively, *autonomy*, or for that matter, *autonomous*. Then there's *autogestion* as well as *abundance*. And some might even say *appealing*. These and other admirable qualities all fit amenably together in formal definitions of *anarchism*.

Concentrating on a single letter *A* seems anathema, however, to coming close to any depiction of the breadth and elasticity of anarchism. As anarchists, of course, we aren't interested in any sort of alphabet soup of hierarchical institutions, with initials like FBI or ICE, NATO or WTO, nor following the letter of the law. Still, even when boiled down to our capital *A*—the ideology—we harbor a suspicion that much is getting lost, or that much is getting crushed under what could become a dogmatic boot.

So in walks the lowercase *a*—placeholder for all of those age-old anarchistic practices that preceded dictionaries and certainly never needed a word to describe them, nor do to this day. It humbly offers itself up as a healthy and generative tension to its friend, the uppercase *A*. If we listen closely, we can hear the two whispering conspiratorially together, in what forms the perfect sound of delight, joy, contentment, or to borrow another from our A-list, amazement: *Aa* (pronounced "aah").

Like all good pals, they definitely get into fights with each other—such as who was woke and radical first, or who's the real deal. Sometimes they tussle with a holier-than-thou attitude, or at other times, need their own space, or even stoop to ignoring the other. Yet it's only because they are so similar, and ultimately, because they love, admire, and need each other. And because whenever they have conflicts, the

two are wrestling constructively with real-world dilemmas that neither, alone, can understand, much less potentially speak to.

Our big A, among so many other things, is a bold, assertive, stand-up fellow. It sees itself as following in the footsteps of a political philosophy that not only knows its family name—anarchism—but also its culture and tradition. It can point to its parents and the initial generations before them, and trace a history of diaspora from its birthplaces to nearly every corner of the globe, all the while sticking steadfast to its ethics. It is proud of its legacy and who it is, and absurdly generous in always wanting to share that with others. Our big A is nevertheless a youngster, really, in the scheme of things—barely two hundred years of age—even if it likes to boast of inventing the circle A, itself a mere toddler at well under a century old. It doesn't have enough perspective and experience to draw from, which sometimes can lead to hubris.

Our little *a*, on the other hand, brings millennia of wisdom with it. Indeed it is so ancient that it has forgotten where it came from, and in this way is freed of baggage. It cares not a wit for labels or symbols. It only knows that it has appeared organically and continuously, here, there, and everywhere, long before humans had spoken and written languages, or language at all. It revels in its border-crossing freedom, its spontaneous and shape-shifting spirit, borrowing from all sorts of experiments, and creating new ones. For our *a*, it's all about practice as testing ground for ethics.

When our A and *a* collaborate—for how could they not?—what we get is ever more beautiful approximations of freedom—the delight, joy, contentment, and amazement of many *aha* moments!

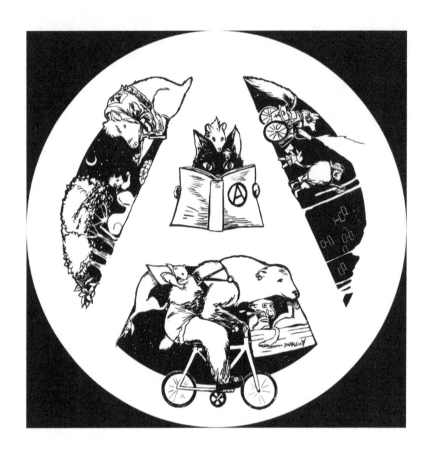

Circle A by DoublewhY_Y

Doing is always with others; it's the joy of sharing—food, knowledge, skills, art, and experiences—with no strings attached.

DoublewhY_Y is a pirate of outdoor advertising, creative vandal, and cyberwitch bitch. Author of *Animal Squat*, an illustrated tale about life in squats (available through Dog Section Press). Part of the collective that created StealThisPoster.org, a free-of-copyright poster archive that provides free guerrilla communication and design services for radical activist groups.

3 | REACHING FOR THE STARS

In the somewhat-distant past, when the political philosophy of freedom was born and given the name "Anarchism" as a baby, it was described by some as "the idea." An idea, according to philosophers over the ages, can have many dimensions, ranging from immediate sensations or reflections, to something that gives form, to a transcendent concept or even the highest realization of a concept or ideals.

But what do philosophers really know (at least those who only talk about the world)?

It could be as simple as what the infant Anarchism's first words might have been, said with a twinkle in their already-mischievous eye: "Hey, I have an idea!," as they scampered off to play with all the ideas they'd absorbed from listening to stodgy adults read far-more-imaginative children's books to them.

Which may or may not, in turn, explain why anarchists love books so much!

If you read—or write, or fill a social center with, or freely distro—books against the grain, their pages can overturn all sorts of established orders, like toddler Anarchism joyfully kicking down a tall wall of blocks that their parents keep trying to erect.

Books—ideas—aren't enough. So as Anarchism grew into an even more disobedient—or shall we say, self-governing—preteen, they perchance leaped onto a bike (maybe even with a couple of their equally troublemaking friends), ditched the discipline of schools, and rushed headlong into all sorts of make-your-own adventures, boldly proclaiming that anarchism was all about "deeds."

Anarchism, like books, gets dusty if stuffed away inside some deadening academy or left to linger as an idea on any shelf. One has to spread the word!

Thus as Anarchism threw themselves into the ungovernability of becoming a teenager—or shall we say, their sense that anything and

everything is possible, as if there was a fire in their belly—"propaganda" became all the rage. Ideas, after all, are so much more accessible when writ large with spray paint across walls, passed from hand to hand as gifted zines or homemade patches, or shared abundantly as the fruits of our scavenging and foraging labor.

For propaganda isn't mere words, whether printed on a page or spoken at a bookfair (essential as those spaces are). Often it's not words or ideas at all—not explicitly.

It's our pal Anarchism, now traveling into their young adult years and beyond, throwing back a Molotov cocktail with their friends—to relax, mind you, after a long day of sabotaging their boss's workplace or self-managing a collective bookstore—to celebrate having liberated a building for communal housing, or having cobbled together an autonomous camp within an at-risk forest and savoring mutual aid under the stars.

Because the idea of anarchism, at any and every age—as our buddy Anarchism hopefully ages well, increasingly loved and cared for by a wider, bigger, ever more beautiful and reciprocal chosen family of accomplices—is nothing short of continually reaching for the stars, with the point being to change the world around us. Anarchism, its ideals, must always be brought to life, as life, with all the creature comforts for everyone. Or as our now-older Anarchism might proclaim to all who will listen, "Out of the books and into the streets!"

(Though read a fucking book—or lots of them—too!)

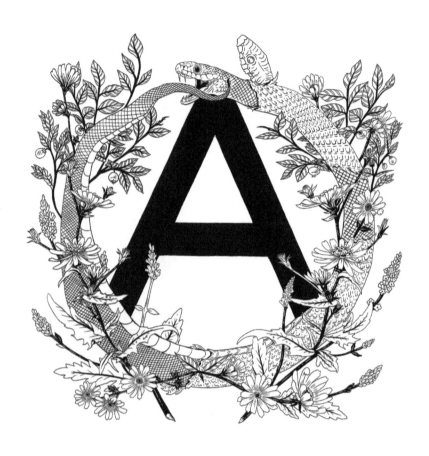

Circle A by Em Varian

Highlighting unity and community care, and showing what new growth could come from shedding the current systems we live under by creating our own.

Em Varian is a queer printmaker and illustrator working in western North Carolina. Their aesthetic is inspired by nature, magic, and resilience, and often includes empowering, trauma-releasing symbolism. They believe that art is a tool to promote awareness of social justice causes, find solidarity with others, and build community. You can find them on Instagram @sharpieharpy. Em would like to thank Firestorm Books for the Ouroboros inspiration.

4 | ONLY A BEGINNING

There's a peculiarly similar sensation that electrifies many of us when we first become an anarchist. The words we use to describe it may not always be the same, but the feeling goes something like this: "It was a light bulb moment." It's as if the whole of the many discomforts we felt with other, earlier political engagements, yet couldn't quite pinpoint, are suddenly made clear by all that's bundled within *anarchism*, from its history and ethics to its practices.

Yet that's only the beginning. Or *a* beginning.

To become—and especially stay—an anarchist after that "switch" has been flipped, something else has to happen. We must shed our skin. We must grow. And not just once.

Snakes, among other creatures such as crustaceans and some insects, are no strangers to this continual process of *ecdysis*. Like escape artists of sorts—or anarchists dressed in black bloc who need to make a discreet getaway after a direct action—they are adept at regularly discarding their outer garments. And to do this, snakes may hide, or become more wary and defensive, eerily like anarchists who are trying to evade surveillance, police, and state repression when in the act of, well, a not-so-legal act.

Shedding our skin, however, is less about getting out of something, even though that's part of the root of ecdysis. (For instance, snakes discard their old skin partially as a form of harm reduction to rid themselves of parasites.) It's about growth, or more precisely, casting off what we have outgrown in a process of repeated renewal, repeated beginnings.

That doesn't mean becoming an entirely new person—or snake. In the snake's case, as they grow, their skin doesn't follow suit, and so they outgrow a part of themselves. They can look back—quite literally—at the "shell of the old" and reflect on what they've chosen to leave behind, or perhaps they can glance at their own reflection in a mirror-still stream and see what they've chosen to slowly but surely slither toward in refashioning themselves so as to better thrive in their ecosystem.

We humans are not quite so dramatic. We grow and change, yes—shedding millions of microscopic cells per day—but for too many of us that usually means staying within the skin-tight constraints of the current social order because we fail to see what we can discard on a macroscopic level. Until or unless we become anarchists.

Then like our friend the snake, we separate ourselves from what now feels a straitjacket: a world that isn't growing with us. As a corollary this necessitates that we, as anarchists, must continually grow and that anarchism itself must be ever dynamic. With each new shedding of yet another layer, we become more aware, individually and collectively, of all that we can happily leave behind.

When we "find" anarchism, our initial snakelike shedding does indeed have a novel quality, like our friend the light bulb suddenly bursting into what feels the most brilliant illumination ever. And that's a warm feeling indeed! Yet if we stop there, at that first flicker, our anarchism and the potentialities it holds out for social transformation will die.

So we shed our skin again and again, looking back with humility at each old layer, marveling that we've not only further stretched ourselves but have done so in ways that stretch the horizons of possibilities too.

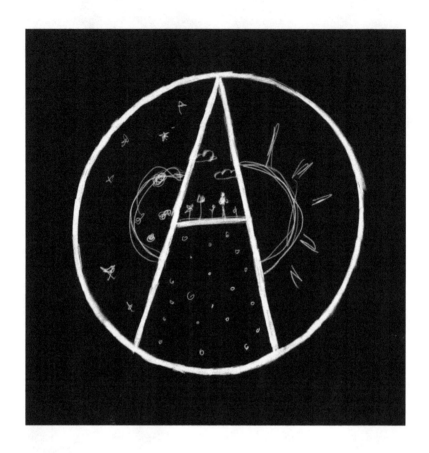

Circle A by Bojan Stanić

Between the sun and moon, we build, we grow, we thrive.

Bojan Stanić is a designer, illustrator, and motion designer for a living, but takes much more pride in his nonhierarchical organizing efforts in culture, politics, and student initiatives as well as his work as a hobbyist musician and writer. Living in the neocolonial hellscape that is Macedonia, he still firmly believes that the only way forward is via decentralized communities where we ourselves make our surroundings more bearable and beautiful to live in. Bojan currently resides in his hometown, Bitola, with his mother, sister, and cat.

5 | ECOTONES OF POSSIBILITY

Anarchism resides in the spaces between, the neither this nor that, neither here nor there, the "no place" that is the root of the word *utopia*.

When asked for blueprints, most of us anarchists will hem and haw as if evading the question. We'll pry open all sorts of portals instead, welcoming others to join us in gazing at magnificent, promising vistas in all directions, neither just backward nor forward, neither simply up nor down. We'll suggest with exuberance that architectures of possibility—the liminal places between this nightmarish world and dreamy other worlds—aren't built by following a step-by-step mechanical drawing but rather by sketching together.

So we'll grab your hand, gleefully pulling you off to some scrappy hillside overlooking the rust belt remnants of train tracks and factories, now covered in graffiti. We'll invite you to sit among the weeds, taking care to avoid the bits of broken glass and abandoned beer cans. Or maybe we'll bring you to a cherished secret spot of ours along a river, by an ocean, or in a desert, guiding you on the way past low-lying tree branches that might poke your eye, rocks that might trip you up, or cacti that might stab you. Then, with a smile that holds weariness too, we'll point upward and outward, arms spread above our heads like an upside-down *A*. Look, quickly: twilight!

For anarchism finds its muse in that sweet yet ephemeral spot that is neither night nor day—when light is refracted and there's suddenly a magical glow to everything; when we can see anew, bedazzled by all the colors of the world and then some, subtle yet sharp, radiating across the sky in an expansive, indescribable spectrum of potentialities.

Twilight is the portal par excellence made up of generative tensions between brightness and darkness, sun and moon, that evade capture. And in that no place, that *ecotone*—that transitional area where two distinct ecosystems converge and play—a richness emerges, an abundance that no bank vault or capitalist can contain.

Of course twilights, real and imagined, are fleeting. They are mere moments, sometimes mere seconds. They are visions of untold beauty that we might miss if not taking good notice, if not making the time-space for them in between all else that can easily distract and derail us. But perhaps their richness is gleaned precisely from their sublime yet fragile quality, leaving us with a yearning to stretch out those moments longer; offering us that glimpse into what is not only most precious but also seeable, indeed doable, in the here and now, versus some cloud-cuckoo-land caricature of anarchism's utopian strivings.

If anarchism has no easy answers—or in fact any answers at all, but only always more questions and ever more delightful "war stories" told around campfires of those times when we realized the impossible—this isn't what's wrong or unachievable about anarchism. It's exactly what's right about it, or better yet, what's compelling: it borrows from the ecotone created when the luminosity of the sun and glow of the moon walk side by side.

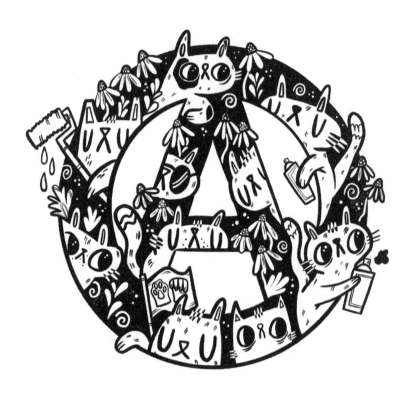

Circle A by the Sabot Cats

The mixture of paint smell and fresh night air is what makes us feel alive.

The Sabot Cats is a laid-back graffiti ensemble, straying in the urban jungle, somewhere out there, beautifying/vandalizing boring gray walls with a message.

6 | ART OF RESISTANCE

There is an art to resistance.

There is an art to a landscape of resistance, or to put it another way, a terrain of world-crafting.

Which begs the question, What is resistance? And also, What is art?

In an ethereal scenario of "full anarchism" where we've abolished, say, all cops, and thus happily get to now read any leftover ACABs hanging around on walls, stickers, and T-shirts as, purely and simply, "all cats are beautiful," we would still have resistance. And art.

Even these presently monstrous days, though, when fascists still roam the streets nearly as numerous as feral felines, both resistance and art can and must be liberated from the damage done to them by non-profit-y activists and high-profit-y galleries.

Resistance, alas, seems to have been reduced by activists to protestation, which certainly has its time and place. Yet protestation directs its gaze toward those in power by either begging like a dog for scraps off a rancid table or letting off steam in the form of rage, tears, or tired chants. Protestation marches in endless circles mostly chasing its own tail (although we do get to find and meet each other, forging trust and social relationships, and that's no small feat).

But resistance, in its artful form, is a collectively and often publicly self-administered shot in the arm, boosting our individual and communal antibodies to ward off the dis-ease (and these days, the diseases fueled by capitalism and its climate of catastrophes) of the current social order. Resistance entails all of those many, varied, creative ways we build up immunity to what harms and ails us, to what's toxic and even deadly. It is each and every instance when we put the force of our own skills and imagination to direct, good—or one might even assert, utopian—use, thereby strengthening the health and well-being of all.

When we do that with dexterity, our forms of warm-and-fuzzy beauty—our artfully executed forms of resistance—frequently take

more tangible hold than their forms of cold-and-calamitous brutality. Our resistance becomes a culture, an art, and not merely figuratively.

Certainly art is metaphoric, poetic, transformative, and so much more that transcends the awful present-day reality, portraying myriad social visions, whether with paint, pen, or performance. Art is simultaneously a social critique, though, helping us paw our way past what formerly we might not have seen and/or all we fight against, toward the *world that could be*.

Yet when stolen away on the walls of museums, sold on the walls of galleries, or even instrumentally employed by regimes or rebels, art becomes declawed. It instead needs to stay sharp, prowling the alleyways in search of scraps of possibility, self-determining its own path, unable to be governed in the service of hierarchs of any breed. It needs to actively, persistently buff over how we see, experience, and live in the current cultural landscape, which itself is intimately shaped by the current socioeconomic and sociopolitical landscape.

Resistance, then, is an art when, and only when, we literally bring to life a culture that is ours—or cultures, for there is no one aesthetic to what freedom will and does look like—across the landscape, across our own terrains, territories, and other autonomous worlds of own collective crafting. That might mean picking up a paint roller or spray can, or it could mean curling up next to one's fellow creatures for neighborhood assemblies or community dinners. There's no limit to realizing our imaginations, especially when we free ourselves to know that our categorically fabulous experiments will never be purrfect, yet they should always be unherdable—not to mention adorable.

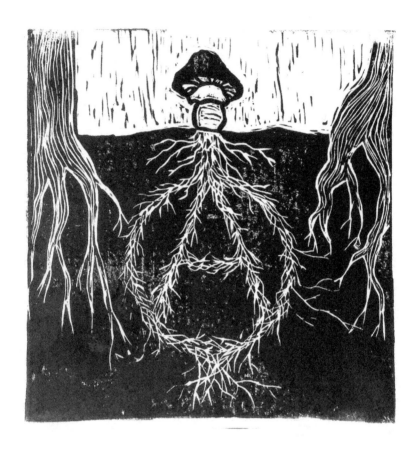

Circle A by momo

Mycelia web beneath the surface, working as avenues of resource distribution and communication between organisms as well as agents of decomposition and remediation to help sustain entire ecosystems.

Momo is an artist, abolitionist, and lifelong unschooler stumbling heart first from one interest to another, and trying to pay rent until we don't have to anymore. She currently resides with her cat and housemates in so-called Ypsilanti, Michigan, on the unceded Anishinaabe territories of Odawa, Bodéwadmiké (Potawatomi), and Meškwahki·aša·hina (Fox) peoples.

7 | SELF-PROPAGATING ROOTS

Anarchism, for all the dirt flung at it by other ideologies, is the only truly radical political philosophy, for it is the only one that gets directly at the very definition—not to mention etymological origin—of *radical*: of, having, or proceeding from the roots. Anarchism never stops rooting around below the surface. With a sharp-edged shovel, anarchism digs down, metaphorically speaking, to the deepest subsoil so as to expose any and all toxic roots that may have taken hold. Anarchism is willing to get muck on its overalls, as it were, in order to zero in on the anchors for any unhealthy growth proliferating and dominating "above ground."

(This might go a long way toward explaining why anarchists seem to prefer subterranean forms of organizing and agitating, or at least why they like to compost, whether food or the state.)

Yet anarchism, as a political philosophy of freedom, doesn't rest there; it understands that roots, when properly cultivated, can themselves be radical. Indeed anarchism would blow away with the first strong wind were it not for the hardy supports that we ourselves foster by continually preparing the nutrient-rich ground for what we know is possible.

We anarchists root ourselves in our own history. Not just those "fathers" of anarchism, or moms, or even parents. Not merely some "classical" anarchism or revolutions, or anarchists in one particular time and place. Or even the invention of the word *anarchism* itself. We anchor ourselves in all of those autonomous rebels who came before us, bucking authority whenever it reared its head, and thinking and acting beautifully for themselves. We find our roots in countless anarchic ancestors—whether in millennia-worth of life-giving and earth-based communal rituals and cultural practices, or centuries of resistance and prefiguration, such as peasant rebellions, pirate ships, bread riots, and barn raisings; underground railroads, sewing circles, industrial saboteurs, and burial societies; maroon communities, volunteer firefighters, strike funds, and prison breaks.

Our ethics, too, anchor us. Not a single ethic, but a mass of entangled ethics like healthy plant roots, together nourishing a liberatory politics. One cannot, for instance, cut away the ethical root "mutual aid" from those such as "voluntary association," "self-organization," and "reciprocity," or one could easily end up with watered-down charity projects. Our ethics form the basis of what could be understood as companion plants, with each one able to stay true to itself because it grows in tandem with the others; none towers over or shades out the others, as if somehow superior—however benevolently, able to dole out sustenance or death—but instead offers mutualistic benefit, including by demonstrating that a biodiversity of ethics is essential for maintaining the fecund soil of an egalitarian politics.

Those ethical roots, though, will dry up and wither if they aren't parts of living ecosystems. Anarchism has always, also, rooted itself in our self-determined interrelationships and interdependencies, in how we practice new forms of social relations and social organization. In fact, it's impossible to untangle our ethics from our practices, our practices from our ethics; both conduct nutrients to each other and allow for growth. So we nurture all sorts of self-propagating roots—in friendships and neighborliness, collectives and communities, social struggles and prefigurative experiments. The roots we form in this way are rhizomatic—organically self-organizing, spreading out horizontally, and sending out new roots and branches of inspiration in various directions as they spread, meaning in turn that others are given encouragement to organically self-organize, spread horizontally, and send out new roots and branches for others, and on and on, thereby interconnecting more of us to each other even as we're all given increasingly expansive space to emerge and flourish.

Hope, or one might say faith or promise, is an anchor too for anarchism. Not some false hope, but the kind rooted in the possibilities that have been realized in the past and present, always imperfect, and yet often perfectly beautiful nonetheless.

Think of this as an anarchist agroecology. Through the numerous ways in which we aspire to get anarchism to take root, we are, from the bedrock up, cultivating a culture in which life can grow and thrive.

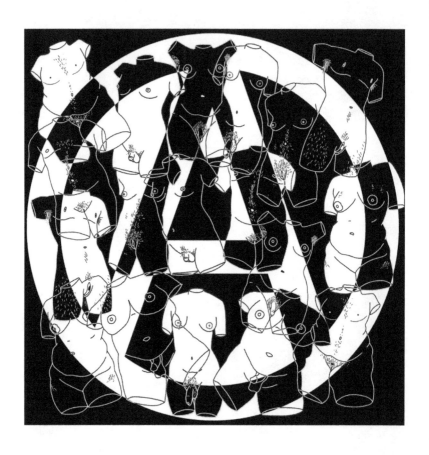

Circle A by Margot Apricot and Callan Moon Rabbit

This circle A celebrates and normalizes trans bodies.

Margot Apricot (Columbia, Missouri) and Callan Moon Rabbit (Salt Lake City, Utah) are two trans artists and collaborators that make body-positive, antifascist, anarchist propaganda and organize among their communities.

8 | IMPERFECTLY PERFECT SELVES

Borders aren't just geopolitical lines on a map, dividing one chunk of stolen land from another, fortified by guns and razor wire and fear of the other. Borders aren't merely the stuff of nation-states and occupations, militaries and police, papers and citizenship or the lack thereof (though they are all that and more).

Borders, if we stretch our horizons, can be walls that people put up all on their own too. Or walls they fail to see, like the gender binary, fortified by what over time begins to appear as natural, mundane, or even normal.

For a border—when defined by anything or anyone with the power to lord over others—is any kind of binary that cuts off routes to self-determination and collective freedom, and has various mechanisms, from soft to hard violence, of enforcement.

When we anarchists joyfully proclaim, "No borders!" or exuberantly assert, "Freedom to move, freedom to stay, freedom to return!" we aren't limiting our dreams to their border boxes. We aren't stopping at some singular border understood as a geographic space between countries.

We are, if we adhere to our own ideals, declaring our dysphoria over all towering borders, whether concrete like prisons or more amorphous such as patriarchy. Yet far more than that we're fabulously embracing our euphoria over all the ways we're journeying, fluidly and by throwing off baggage handed to us by heteronormativity and the ways it demands that we assimilate our bodies to its monoculture, toward heterotopias without borders around gender, sex, and sexuality.

Tearing down such borders isn't, of course, about throwing out boundaries. Our bodies, ourselves, and our communities—if we're true to our aspirations—continually engage in consensually agreed-on forms of voluntary association and voluntary dissociation. Such associations, in contrast to borders, mean that we care deeply for each other's autonomy, welfare, and safety. And when we do need to set boundaries, we aim to transition our associations with deliberate, compassionate,

sometimes slow-moving intentionality so that no one is left uncared for—even if some of us ultimately can't be around each other.

Association and consent, then, become in this way euphoric too. Which doesn't mean easy. It means moving closer and closer to individual and collective well-being, toward a sense of self and social wholeness, which will always take work (of a noncapitalist kind—or better yet, as a labor of love).

Once we've taken our bolt cutters to the walls around gender, sex, and sexuality, and from there discovered the borderless wonder that none of us really fit in the two—or even increasingly, several—boxes we've been given by all sorts of authorities and documents, whether assigned at birth, or consigned to us daily and even in death by the geopoliticization of bodies on the macro- and microlevel, there's no going back, in a good way. As we all venture into the infinite possibilities, the elasticity and shape-shifting and liberation that stretch out tantalizingly all around us, there for us to endlessly and pleasurably cavort with, we realize the naked truth that was there all along: we are not a category, or even a pronoun, or merely an identity. We never were. We are each our own multidimensional, rare, precious person, no two alike.

Maybe "gender" wouldn't even make any sense to us at some point, once we anarchists have helped to knock down every checkpoint and fling open every gate. It would have no relation at all to, for instance, being a parent, friend, playmate, kin, caregiver, lover, or collective mate, which in turn would unfurl into expansive expressions of social relations that we can barely yet conceive of, more kaleidoscopically colorful than any version of a rainbow flag.

Because we'd simply, fully, wholly, and maybe even holy, be our transcendently beautiful, imperfectly perfect selves, in all shapes and sizes and parts and passions.

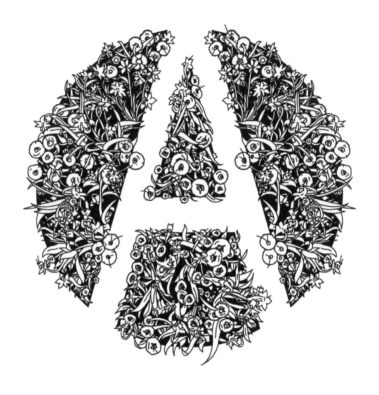

Circle A by Nick Jones

This design represents the beauty of the diversity and wildness inherent in anarchist thinking, and how our differences bring resiliency to our communities.

Nick Jones is an anarchist artist, printmaker, and propagandist based in so-called Salt Lake City, working under the name Surmise Studio. His artwork focuses on exploring new and radical ideas through visual communication. He seeks to find and share the mysticism and optimism that draws people toward anarchist thinking. No matter how difficult the struggle, we can always dream of a better world.

9 | REBELLIOUS HONORING

Anarchism is there for life—abundant life, qualitative life—overflowing any confines we can now imagine for humans and nonhumans alike.

In the here and now, though, when most lives are made undignified, trampled on like so many weeds, not seen for the flowering profusion of inherent worth that each and every living being represents, anarchism is there for death too. That is, the too-early, too-unnecessary, ugly deaths.

Our very symbol speaks to that. The O that circles our A indicates that other forms of social *organization* are possible and even happening now in pockets, always against the constraining box of the dominant structures. Like life, our O revolves around forms of ecological organization as well. That is, the interrelationship of organisms and their environments, social and ecological, so that all can thrive within an intricately balanced shared space, dying in their own good time. Well, not dying per se; rather, (re)cycling us—we humble human beings, as just one small part of ecosystems—through the ever-changing seasons of life, which includes returning us to earth.

So anarchism, at its best, is for the good life and the good death, with the healthy understanding that the two would be inseparable in good communities. Our joys and sorrows would be inseparable. Like when we look down at a patch of ground blanketed in plants at their fullest bloom, and are well aware that their ephemeral beauty—their color, texture, smell, feel, and all else that makes them alive—is inseparable from the fact that their leaves will wilt, die off, and return to the soil, helping to make a good bed for future generations. Indeed, that this brilliant foliage grew from the fertile humus of many ancestors.

In this anarchic ecology, we'd see our interdependent place as mortal beings—from dust to dust, as it were—in what we now set apart from ourselves as "nature." We would certainly grieve loved ones when they die, from flora to fauna to other humans, yet we'd be far better able to integrate these losses as necessary and organic. We'd be intimately part

of the process, bound up in life, within circles of care that eased us into and through death, including with healing arts and comfort, communal mourning practices, and collective, continual remembrance. Death would pain us, but it wouldn't traumatize us; we'd feel embraced by the circle of life—not a perfect circle, mind you, but one that can hold and mend us, and make memory a blessing.

Instead we look down at a patch of ground covered in blood, with a body unceremoniously lying on concrete, encircled by murderous cops. We look down at a patch of ground covered in disappearance, with bones unceremoniously buried underneath, hidden by murderous residential school authorities. We look down at a patch of ground covered in disasters, with bodies unceremoniously piling up from capitalist-fueled fires, hurricanes, floods, heat waves, and building collapses, or state repression.

So we repeat, like a mantra, "Mourning our dead and fighting like hell for the living." We construct do-it-ourselves altars and rituals on the ruins of these bad deaths, and mutually aid the grieving, whether with food, funds for funerals, or making time and space for their emotions. We take our rage-as-grief to the streets in fiery uprisings. We create murals and posters filled with the faces of the murdered, scribing "rest in power" by their names. We yearn, with all of our hearts, for such avoidable deaths to end, and struggle toward that aspiration. And yet as long as they continue to happen we will be there, with flowers and ceremony and rebellious honoring.

Circle A by Daisy Lotta

Anarchism as the constant search for safety and community in a world that makes it hard not to lose hope.

Daisy Lotta makes illustrations and children's books on social justice topics. Her art is colorful and happy, with a radical twist. She wants to share information on total liberation, mental health, and veganism through her drawings, and give hope that a better world is possible!

10 | STICKING SIDE BY SIDE

If under capitalism, as a famous political philosopher (who also wrote the book on the subject) once observed, "all that is solid melts into air," then under anarchism all that is solidarity congeals into airtightness. Solidarity, for anarchists, isn't something that dissolves or disappears, meaning that it's also one of our weapons against capitalism.

Solidity has a twofold quality, which is part of why it's so firm. It involves first taking a side. And from there it entails sticking steadfastly side by side, both with others who are willingly there alongside you and those who by happenstance are being made to suffer the consequences of the opposite side—or *other* sides, because sometimes there are three-way (and more) fights.

That all sounds simple enough. Take a side and then stay side by side. Yet solidarity, like ending capitalism, is no easy task.

One could argue, of course, that it's fairly easy to pick a side based on right and wrong. Liberals don't seem to think so, though; they claim that "everyone's got a right to their opinion," as if there is no right or wrong. Fascists, in contrast, are quite clear that there are sides, albeit based on conspiracy theories, "blood and soil" nationalisms, and other fabricated notions of pure rightness that lead to genocidal wrongs. The state, colonialism, and capital, among others, basically take the side of power and profit, premised on "might makes right." And the debates of how to ground an ethics rage on. Indeed over many centuries, most religions and famous philosophers have written many tomes on the topic, and depending on their own politics … well, let's just say, there are lots of differing and sometimes deadly conclusions.

For anarchists (philosophers of the streets and hearts, as it were), anarchism supplies a set of ethics. Or to put it another way, anarchism itself would melt into air without its far-reaching aspirations of freedom. And not just in theory. Anarchism's intertwined values are only as good as they play out in histories and cultures of resistance, brave

spaces like revolutions and autonomous communities, and other lived experiments and prefigurative practices. They are only as good as they manifest in actually lessening hierarchies and domination in the present—never losing sight of abolishing them—and concurrently replacing them with the presence of things such as social solidarity.

Given this, it's no huge leap for anarchism to take the side of abolition. One only has to glance around at mass incarceration, killer (and all) cops, and concentration camps at borders, to mention a few. That much is easy, at least if one voluntarily abides by anarchism's ethics.

Where anarchism goes the extra mile—and then some—is in how solidly side-by-side it remains, including when that's incredibly hard to do, and including when we'll likely face numerous conundrums. For solidarity under anarchism isn't something extended only to people we like, or people like ourselves, or people whose actions we approve of in full. Solidarity is about sitting next to each other in the comfort and discomfort of making good on our ethics, meaning that solidarity challenges us to continually grapple together with finding congruence between our means and aims as part of the never-ending process of getting everyone free.

Circle A by Timo Bock

Sometimes a hug, a pat on one's shoulder, or even a glance into each other's eyes can be an encouraging and powerful gesture in times of struggle.

Timo Bock is an illustrator, graphic designer, and printmaker currently living in Hannover, Germany. He sometimes provides artwork for political groups and movements. Using mostly linoleum or wood, his work has a rough, handmade aesthetic and circles around everyday utopian yearning as well as dystopian facets of our capitalist society.

11 | BONDS OF TRUST

Embracing anarchism is often made far more difficult then perhaps it should be. To get involved, there are no party headquarters to walk into or candidates imploring you to pound the pavement for them. One isn't sold a newspaper and taught a party line by a cadre in order to gain admission. There isn't a nonprofit with a comfy office and paid volunteer coordinator ready to tell you what to do.

Sure, you'll likely find anarchists filling up a community fridge, restocking harm reduction and safer sex supplies at a social center, fixing up bikes or giving away shit at a really really free market, packaging up books to mail to folks in prison, handing out water and surgical masks at a protest, hosting art builds to support pipeline struggles, gifting zines at an anarchist café or herbal tinctures after a "natural" disaster, seed bombing and guerrilla gardening, painting murals to honor our dead—until it will seem, once you start noticing, that anarchists are everywhere. Everywhere, that is, where one finds fun stuff like mutual aid and social solidarity.

Yet when those curious about anarchism ask, with eager-eyed enthusiasm, "How can I join?!" not infrequently they'll be met with some version of this advice: "Find your friends."

On the one hand, this counsel can be viewed as a failure of anarchism. Certainly, for example, while there are indeed friendly anarchists as well as anarchist spaces that welcome and mentor new generations, there still aren't enough of them.

But let's focus on the other hand—the one that holds your shoulder when you're going through hell, grasps your hand to scamper away together from danger, or gives you a high five when you're down. The one that lends itself with warmth when you most need support.

Friendship, expansively understood, isn't something taken lightly by anarchists. It is at the heart of what makes all else possible, from communion and care to communes and commons.

This springs from the fact that anarchism doesn't come with warranties or insurance policies—whether pieces of paper or entities outside of us that purport to repair the world and forever keep it that way. Nor, unlike other political camps, does it liberally dispense the snake oil of false guarantees, such as via supposedly easy answers like election days or legislative bodies, treaties or human rights conventions, or charismatic leaders, despotic or progressive. We humans can act in the best and worst of ways; no form of social organization provides surety that our beautiful, albeit imperfect, sides will largely win out over our brutal urges.

What anarchism relies on instead are bonds of trust. Without such voluntary bonds—reciprocal promises that we can rest assured in each other, come what may—there is ultimately nothing to hold any anarchist project together, much less any sort of self-governing autonomous community. And there's no better place for nurturing and honing trust than in our friendships, whether between pals or partners, kin or neighbors.

For there's something freeing about friendship, unlike other social relationships. To become friends means to fully open oneself up to all sorts of mutualities such as mutual care, mutual goodwill, mutual self-disclosure, and mutual affection. When, over time, we repeatedly make good on our mutual obligations, share in mutual pleasures and hardships, and come to expect mutual cooperation, we solidify a mutual intimacy: bonds of trust. In this way, friendships allow us to be vulnerable and brave, like being encircled in the tenderest yet firmest of mutual hugs.

By "find your friends," then, anarchists mean joining together in forging bonds of trust. They mean, "Let's toss stones into the wide-open seas of friendship, and delight in the concentric circles that grow wider and wider because of us."

Circle A by Nevena Pilipović-Wengler

The roses themselves nod toward socialism while the hands' offering of roses to each other nods toward mutual aid and the communal interlinkings of anarchism.

Nevena Pilipović-Wengler print makes and illustrates, often around disability justice and labor movements. When not making art, she tries to exercise political imagination in urban planning, holding the dialectical conversation between socialism and anarchism in her practices.

12 | SWEETNESS OF BORROWING

Borrowing is a time-honored tradition within anarchism.

On the one hand, it takes the sweet form of practices that are the equivalent of asking your neighbor if you can borrow a cup of sugar. Here it's less about the material benefit, and sometimes not at all (like if your neighbor doesn't have sugar), or even having to return a cup of sugar later. It's about having good and reciprocal enough social relations with your neighbors to even be able to ask this in the first place and know that they can likewise ask this of you. If you do this frequently enough, the easier and more routine it becomes to happily rely on each other for all sorts of things, material and immaterial, making for "exchanges" you look forward to and even seek out, enriching your lives beyond anything money could ever buy. The sugar is almost an excuse, whether for conversation, connection, or deepening community.

Anarchists extend this type of informal one-on-one borrowing when they, for instance, self-organize a tool-lending library with their neighbors. It's not just that folks voluntarily pool everything from wrenches to ladders, and then freely use and return them. It's that they need to know and trust each other, and/or better get to know and trust each other, in the process of collectively determining, say, where best to house the library, such as perhaps in an unlocked shed in someone's backyard. As neighbors increasingly come to know and trust each other, they begin to realize the bounty of the gifts that everyone has, from hammers to building skills to making sandwiches for those doing the construction work or cheering them on, and so much more, and that these countless gifts mean there's more for all and almost always enough.

Borrowing, on the other hand, can take what might be considered an even sweeter form: the lending of good ideas beyond one's small social sphere, and the joy in witnessing others freely pick them up and imaginatively run with them. Indeed, the joy is in watching these borrowed ideas begin to have a life of their own and yet retain a sense of the social

relations that weave us wonderfully together in ever-widening circles.

For example, anarchists didn't come up with the phrase "Bread for all, and roses too." Suffragettes first began singing the praises of this idea. But the sentiment grew from there, spreading without possessiveness among trade unionists, strikers, and famously a poet, whose lines became the lyrics for an oft-covered song among all sorts of rebels.

Of course, anarchists were among these borrowers, yet rather than letting "bread and roses" linger as a slogan, they put it into practice. After all, anarchism aspires to meeting not only needs but also desires, and has never been good—typically in the best of ways—at distinguishing between the two. What one person understands as a desire, is for another person a need. Take books as one illustration. Aren't they both? Or for that matter, the need and desire for delicious home-baked bread made from one's own sourdough starter to share with friends, or bread fresh from the oven of a bakery attached to a socialist-anarchist labor hall, as opposed to the mass-produced white bread of capitalism.

So an idea, just a twinkle in some anarchist collective's eye, is transformed into, say, the first-ever Food Not Bombs project, with the ingredients borrowed—like a cup of sugar, but from a neighborhood dumpster, food bank, or grocery overstock—and cooked into shared public meals and, crucially, autonomous neighborly gatherings. "Wow," exclaimed other anarchists in other places, "let's borrow that concept!" Soon Food Not Bombs projects circulated freely and widely, each creatively repurposed for its context and yet all interrelated, not simply by name, but by familiarity as well as aims. Food Not Bombers also began to circulate freely and widely between each other's cities. Over time, the idea was even more expansively borrowed, morphing into additions like Coffee Not Cops and Food against Fascism, and of late, outdoor free fridges.

All of these projects become like neighbors, always at the ready with a cup of sugar, but importantly, also ready to borrow moments of each other's time for a friendly chat, and more important still, with roses at the ready. Stop by a Coffee Not Cops and you're just as likely to share in sweet rolls. Or peek into a free fridge and you might just find flowers next to a big bag of flour.

Circle A by Sara Jean

Keeping anarchy warm in our hearts through these harsh times.

Sara Jean is an embroidery and print artist who lives in Washington, DC—occupied Piscataway land. She is a rad mama who enjoys strolling on sidewalks and marching in the streets. Her work can be found on Instagram @BySaraJean.

13 | UMBRELLAS OF PROTECTION

When it rains, whether from capitalist-fueled hurricanes or the tear gas that cops shower on protesters or our own tears after another murder by a white Christian supremacist, anarchism pours its heart out. It is in such torrential storms of disaster that anarchism shines.

This is not to say that anarchists supply nothing but smooth sailing when the waters are rocked by disturbances. It is instead to assert that when lightning strikes, which it does with far more frequency and deadly accuracy than we'd like, anarchists are typically the first to pull out their umbrellas, holding them over whoever happens to be nearby, getting drenched. Indeed, anarchists welcome as many people as possible under these figurative umbrellas—or literal ones, such as when holding the line during an uprising. We know that protection stretches much wider, much stronger, when it embraces friends and strangers alike in a canopy of communal self-defense.

Sure, sometimes our umbrellas get stuck when we try to open them. Or one of their ribs gets broken, and we're only partially able to shield those below from inclement conditions. Or the fabric is frayed or even torn in spots, allowing some of the messiness of the world to seep in. All of this can, no question, dampen our mutualistic spirits.

Yet by and large, anarchists never lose sight of which way the weather blows and the need to offer collective shelter, and the knowledge that such moments are in fact the test of our solidarity, which is to say, the test of our love. For it is relatively easy to say that you'll be there for people when all is sunny. It is another thing altogether to willingly make good on that promise when the sun gives way to foreboding clouds, the clouds unleash their fury, and we become soaked to the bone.

Our forms of community self-defense are, of course, as varied as our microclimates. Still, they share an unflinching dedication to ward off collective attacks while simultaneously cultivating healthy ecosystems

in which everyone feels as if everyone else has their back—even and especially when it's scary or dangerous or tough.

This voluntaristic protection, more often than not, isn't about extravagantly or boastfully waving around one's black umbrella like some anarchist flag. It is inseparable from a voluntaristic humility—the belief that such solidarity, such love, is something that everyone should do by virtue of being human, sociably caring for others of our species, without need for anarchism to somehow get credit. Anarchist umbrellas pop up in quiet ways—usually invisible, although always embodied. Which typically translates into people who aren't anarchists feeling wary at a march, say, that "the anarchists" will show up to cause trouble, when meanwhile they are surrounded by anarchists who are already there doing all, or nearly all, of the infrastructural work.

This looks like collective legal defense when hundreds get arrested and face years behind bars, even if we don't know each other or all get along, yet also collective support to ease the burdens of the codefendants as much as possible. It means using bike or car blocs at a protest as the first line of defense against any fascist who might try to drive a vehicle into the crowd, but equally having medics, food and water, safe houses, and other collective care on hand for physical and emotional aid. It ranges from engaging in transformative justice experiments in order to collectively get better and better at generative conflict, to organizing mutual aid disaster crews amid collective loss, to making and holding space for processing collective trauma and grief. It looks like this and so much more.

Because way beyond anything the postal service delivers on, anarchists are there come snow or rain or heat or gloom of night.

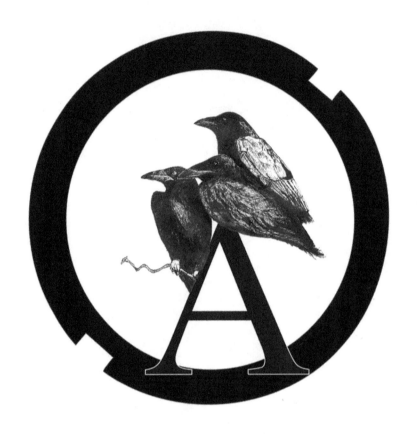

Circle A by the Black Spoke Collective

The convergence of cycling and radical politics revolves around an A for anarchy (of course), a lock ring from a bicycle, and the love of animals as depicted by the crows.

The Black Spoke Collective, made up of friends from St. Pauli, Hamburg, is incredibly passionate about cycling—not as a sport, but as an identity, or a sort of positive nihilism against a world and its paradigms that have long since stopped making sense. Autonomous, nonprofit, and DIY, the collective tries to spread its radical political mindset into the wider cycling community. Collective members are outspokenly anarchist, antifascist, and (intersectional) feminist, and big on animal rights. They take back the streets, the night, and their own lives

14 | SOARING EVER HIGHER

Anarchism gives us wings to soar higher and higher on all the currents of possibility, past, present, and future, and there is nothing so whole as this sensation of feeling alive and free. Yet it also means gaining the ability to perch ourselves far above the world and see the bigger picture—the vast terrain of all those hegemonic structures and forms of socialization that so violently overdetermine our profane existence, not how we'd want it to be in our flights of fancy. And as the saying goes, though nonhierarchical speaking, "It's lonely at the top."

This is the bittersweet beauty of anarchism. The more we become awake to the world, the more we get to take in both new heights of liberation and ever-wider landscapes of suffering. And the more we learn to scan the human and nonhuman condition for the good, bad, and ugly, the more we can't look away; the more we perceive and feel, the more we feel compelled to accompany those in pain.

Of course, there is a bittersweet beauty to life in general, no matter where we find ourselves. For life—that earthly existence that is breathed into us at birth and breathed out at death—is not constituted to shield us from agony and ecstasy, and everything in between. To experience the whole remarkable package of life, we must open ourselves up to loving others, knowing all the while that we are opening ourselves up to eventual loss and grief, if only because we are mortal.

It's an entirely different matter, though, to fly directly into the winds of bittersweetness, not merely to deeply experience the inevitable poignancy that comes from being alive. Rather, to deeply see and feel all the unnecessary hurts that no one should have to endure, and to know—because we can now see a great distance ahead—that they could be avoided if others, too, could see what we do. That is almost unbearable, achingly so, and brings with it mighty obligations.

Hence the lonely perch of anarchism. Few will feel called to this fragile limb, hardly able to bear the weight of the dangerous gift they will be

handed—the same kind of dangerous gift handed for centuries to seers, prophets, and diviners, keepers of the flames and holders of the stories, heretics and healers: a painfully far-reaching vision that has the power to destroy and create.

To use this dangerous gift wisely, to know what contributes to ever-greater well-being for all, versus what further rips societies to shreds, we cannot be alone in our loneliness or we will lose all of our bearings.

So even if there are relatively few of us anarchists, we make sure to gather atop our lonely perch as often as possible—whether in small forms like an anarchist affinity group, book club, or potluck, to larger ones like an anarchist bookfair—to balance each other out and aid us in not falling, in staying put. To point in the distance to things each of us might have missed seeing, despite our bird's-eye view. To expand our sense of direction and horizons. To affirm that we're where we need to be, must be, are obliged and honored to be, because all of us heeded the call, took up this calling, broken wings and all, to soar ever higher toward mending the world.

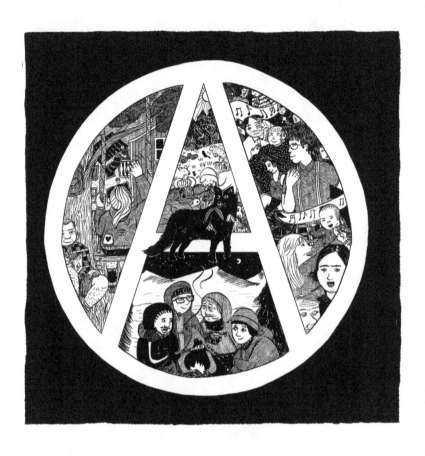

Circle A by Ane V.

No longer will our bodies be governed and shackled; we will feel the grass under us and hold each other for as long as we need.

Ane V. grew up north of the Arctic Circle surrounded by the ocean and mountains, but now resides in a small village outside Umeå in so-called Sweden. They make mostly autobiographical comics and love drawing loads of people together. Ane also love zines, making music, shoveling snow, getting lost in the woods, long and passionate discussions, and dismantling the class system.

15 | DECIDING FOR OURSELVES

Direct action can be seen as having two dimensions, even if they both frequently conspire together.

There's the "negative" angle wherein our actions directly disrupt and even shut down all that doesn't spark joy, to put it lightly. And there's the "positive" aspect wherein our actions directly open up room for blissful other possible worlds—not merely in our hearts, but in our actual lives. The shorthand version goes like this: "Fuck shit up *and* fix shit up." Because one can—and should—do both at the same time, like blockading an oil or gas pipeline from being built by constructing and making good use of a healing center or encampment directly in its path, or stopping a forest from being clear-cut by patching together and inhabiting a neighborhood of tree houses directly in the at-risk branches.

Yet the highest form of direct action—in a freedom-striving, not hierarchical, sense—is when those dimensions achieve enough power-from-below to establish physical spaces held together by ongoing forms of self-governance. That is, when we have collectively transformed—after much struggle and, for sure, direct actions—a village or city, region or unceded territory, into a face-to-face autonomous community in which we are routinely deciding for ourselves.

Such directly democratic communities are also the highest form of joy—in a freedom-loving sense. That doesn't mean that all is now perfect and harmony reigns; or that everyone is somehow always happy, with nary a care; or that people won't have to face all sorts of ethical dilemmas.

It does mean, though, that contrary to the tropes of drudgery about such spaces—like "life will be a series of endless assemblies"—people are freed up to think and act for themselves on a daily basis in all aspects of their lives. And when people know that they're getting to decide everything for themselves, they're able to fully realize the delightfulness of self-determination, including that many minds really do make for far more creative, solidaristic, and collectively caring decisions—and ones actually relevant to the life of the community.

But where the heights of joy are most evident in this highest form of direct action—self-governance—is in the substance of what we decide when everything really is directly left up to all of us. We decide on supplying as much of what everyone needs and desires as we can based on our intimate knowledge of each other, and what we have in plenty, lack, or are able to produce. We determine the size and shape and structure of all that our community is passionate about, from the arts and education, to accessibility and accountability, to festivals and other communal gatherings. We decide, in short, on bringing as much pleasure and satisfaction into the everyday as possible.

Again, this isn't the same as "happiness." There will be sad days, like when two buddies are experiencing a rough spot in their relationship. Or when we lose communal crops to our neighborhood critter friends, or are feeling down due to an absence of sunshine and abundance of bitter cold in midwinter. Or when someone feels exhausted because the queered childcare system we all dreamed up isn't quite living up to our expectations.

On all types of days, we'll find joyous comfort in the ways we decide to respond. Our two buddies, for instance, might be able to lean on the culture of generative conflict that the community has embraced and thus be able to reach out to a pal across the way for mediation aid to help them regain their pleasurable companionship. Or we'd decide to throw a harvest festival to celebrate the satisfied tummies of our animal friends, flinging open our cupboards to make a bountiful community dinner and laughing while we glean the fields for anything that was missed. Or we'd rely on one of our many self-determined "public works" like communal fire pits well stocked with firewood and marshmallows to beat the winter blues. Or we'd revisit our childcare decisions, realizing that what we need instead is multigenerational care, and set about creating all sorts of playful spaces to tend to each other.

Circle A by Blowing Dust Area

Playful possums sharing food and affection, vibing with nature and eating trash.

Blowing Dust Area is a lifelong inhabitant of the Sonoran Desert, occupied Tohono O'odham land. While possums don't reside here, this desert has some possum-like creatures, such as the fluffy but formidable skunks encountered at campsites and more secretive yet communal bands of long-tailed coatimundis. Like many anarchists living under capitalism, Blowing Dust Area can relate to the possum experience—at home in the wild, eking out a living however best they can, and often scavenging to create a nest, all the while finding ways to share love and community.

16 | SERIOUSLY PLAYFUL

If anarchism never grows old, it's due in good measure to the role of play in keeping it forever young at heart.

Play isn't frivolous or only child's play. It has all sorts of healthy benefits, individually and communally. Play activates both our social vision, by exercising our creativity and imagination, and our social critique, by keeping our critical thinking limber. It encourages cooperation, from learning and problem-solving together, to self-organizing when, where, and how we play, to sharing things like toys and equipment, to looking out for each other's enjoyment and safety, to gleefully monkey wrenching what we need as a group to make mischief. Then, too, it lets us play with power dynamics in consensual and often silly ways so as not to carry them into the rest of life. Play also supplies us with somatically pleasurable paths toward emotional well-being and intelligence, and keeps our memory fit.

It's no wonder, then, that the adult-powers-that-be, whether playing games with our lives inside a capitol building or boardroom, promote work as we "grow up," wanting us to play dead so that they can better tame and control us. It's a wonder, in fact, that play isn't illegal! For it contains all the healthy ingredients for ungovernability!

So is it any wonder at all that the wonderful spirit of play pervades anarchism!?

For one, it's a fabulous way to welcome people into our circles. Many a stay-in-line authoritarian communist or buttoned-down social democrat has become caught up in the joy of anarchism during a protest—and soon after, joined the A-team. Whether it's our ragtag anarchist marching bands or other cheerful noise, impromptu games of anarchic soccer to halt business as usual, or hockey sticks used to hold up placards, we make it a hell of lot more fun to be at a demo. Or as speakers droned on at a rally against immigrant concentration camps, for example, some anarchists in one city set up not only a festive table of free zines and stickers but also a

game where kids of all ages could test their acumen at snipping through an actual piece of wire fencing using bolt cutters.

Games are a great way for us anarchists to stay, well, on our game. Just before a huge antifascist convergence, a crew of anarchists played Bloc by Bloc, and while there's no hard evidence for this (especially because they lost the board game), they managed to evade the real-life mass arrests the next day.

Play lets us celebrate as well. One May Day, for instance, many anarchists turned the streets of their downtown into an enormous Pac-Man game. At 5:01 on 5/1, various humorously themed and costumed-up blocs took off on foot from separate points—none of them knowing where the others had started. The goal was to find each other, but during that search, gift stuff like pastries and roses to passersby, or add graffiti and stickers to walls. The police decided to "play" as well, but they weren't good at Pac-Man. The blocs outmaneuvered them, time and again, to much merriment, and when all the anarchists merged into one big happy family, a dance party ensued in a now-blocked intersection.

And games, to mention one more illustration, allow us to create autonomous space, such as the collective of teens and teen-like folks who regularly squatted parks after dark—when it actually is illegal to play. They dragged along water, snacks, and first-aid supplies, but also heaps of milk crates, which may or may not have been legally obtained. The crates were the basis, along with playgrounds, for all sorts of low-, medium-, or high-risk self-invented games with amusing self-invented names. These evenings were invariably boisterous, with kids from the neighborhood scampering over (sneaking out?) to excitedly join the mayhem. Yet no matter how rough and tumble it got, the kids respected each other's boundaries. No matter how loud the laughter, the minute a kid said, "Stop, my glasses fell off," everyone instantly quieted down to help search.

Play is seriously one of the best parts of anarchism. It reminds us that sometimes we win.

Circle A by Ira Clarke

Inspired by community gardens that grow free food for their neighborhoods, this piece honors the anarchistic nature of them.

Ira Clarke makes art that focuses on harm reduction, neurodivergence, and anarchism. They enjoy flowers blooming in spring, everything about cats, and thinking about outer space.

17 | COMMONS OF CARE

When people struggle to liberate themselves it frequently involves tearing down brutal divides, and not in a figurative sense. The fall of a wall may in fact represent the pivotal moment of a regime's demise, even though years of dogged resistance have gone into building enough grassroots tenacity to be able to turn concrete blocks into rubble. Too often, however, what's waiting on the other side for people isn't liberation at all. It's *freedom from* one state, along with its "public-private" property ownership and control of land, only to see an allegedly improved version installed in its place with ever-higher fences.

Critical solidarity with such struggles means not abandoning one's own egalitarian strivings yet nonetheless supporting fights for self-determination—that is, until walls tumble. Once those barriers are breached, anarchists and like-minded others aspire to so much more than liberation. We see in the debris all the materials to construct a world in common, wide open and welcoming to the *freedom to* imagine and implement all that people themselves dreamed of while suffering through and defying tyranny.

And so we journey into this now-unimpeded landscape with all of those who didn't go to battle merely to enclose their lives again.

Together, we look backward through the many holes in the twisted metal of a former fence or gaps between the piles of brick from what once was a wall, and begin to not simply remember the stolen past of whatever lands we're on. We also throw ourselves into helping to re-member those lands, for they were never meant to be cut off from themselves, nor from us and other living beings.

Vistas become visible anew, as we eagerly, though gently and respectfully, try to mend the gaping wounds left by the audacity of borders. We not only clean up the mess but engage in rituals of cleansing too, whether solemn or festive or both. Perhaps we then let ourselves

and the land rest, allowing our patience and the webs of life to aid in self-determining what should emerge next.

For we are not alone in tending to and especially honoring this hard-won commons, which has been freed alongside us. Nor is it ours alone, or worse, a select few with a map, deed, or army. Gone are the lines that stifled the free use, sharing, and enjoyment of all that surrounds us, east, south, west, and north.

Suddenly, a riot of re-membering is unleashed, at first with slowness in this new calm, like a cat leisurely flexing its paws after waking from a nap, and then with dizzying speed, as flora and fauna, waters and skies, are no longer held captive.

Vines creep happily across what was an impenetrable divide, unstoppable in their exuberance to weave themselves in embrace with whomever they meet. Roots take hold again, luxuriously stretching themselves out with abandon, always glad to connect up with their neighbors. All that is indigenous gets its own land back as everything from medicinal and edible plants to sacred places delight in not ceding another minute to anything but repair and reharmonizing. Birds and all other beasts now have utter freedom to move, migrating to whatever comfy spots they might fancy, or the freedom to stay, crafting elaborate yet sensible homes from the found materials all around them, or the freedom to do whatever combination feels right for a change of scenery or season. Even the tiny inchworm can now stroll for miles on end, never encountering a ruler.

We rip down as many fences and walls as we can because we know that when lands are liberated, we are left with the freedom to revel in our shared abundance and interdependence, our shared wisdoms and capacities across all species, and our shared needs and desires to live our lives in common, on commons of care.

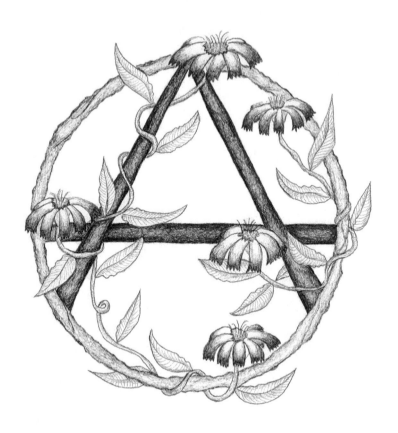

Circle A by Umi N-L Molter

Anarchism is alive, as the wildflower impossibly blooming between the cracks in the pavement before the sterile prison of capitalism and the sweet smell of solidarity.

Umi N-L Molter is a queer, nonbinary artist and social worker from Florida currently living in Granada, Spain. Things that inspire them include faces full of emotion, heated chats about relationship anarchy, the dark part of their sexuality that doesn't express itself much outside of their art, the smell of wet earth, and being able to support people through challenging times. They create out of sheer need, as a coping skill and way to make feelings visible. You can find more of their work on Instagram @glittery.spit.

18 | ECOLOGICAL TOOLBOX

When confronted with a new conundrum, we anarchists are generally eager to wrap our collective heads around it, brainstorm and deliberate about various solutions or at least work-arounds, and crucially, shape-shift our tactics and strategies based on the particular context. This tendency toward openness is because we take our lead, as it were, from nonhuman nature: change is a constant, alive with potentialities.

Within a healthy ecosystem, such dynamism—including when confronted with a "problem"—is what allows for the unfolding and sustaining of symbiosis, an intimate union and harmonious interdependence between all living beings along with abiotic ones. In this striving toward fecund life, the earth is ever in motion, ever reinventing itself, continuously evolving on both the micro- and macrolevel to keep its balance (especially against the force of nature called human beings).

As one humble part of—and contributor to—the well-being of ecosystems, we're willing to not only constantly reinvent ourselves but also forever tinker with the tools we bring to the task of (re)harmonizing the human and nonhuman worlds.

That doesn't make for easy going. (Nature never "promised" us that change would be comfortable.) For us rebels, just to keep our toolboxes full and relevant for the never-ending job of transformation is difficult in and of itself, not least because we have a long-standing love-hate relationship with technology. Yet this is exactly the right sensibility. There is an art to applying human knowledge to practical purposes, and hubris has too frequently led people to do it without care for this planet and its innumerable cohabitants.

To be an anarchistic inventor, then, is be perpetually mindful of the double-edged sword of technology. It can allow humanity to engage in the communal defense of the earth or, as is ever more apparent, its offensive demise. Take the seemingly gentle windmill, which has been around for millennia. In its small-scale form, embedded within commu-

nities, it could do useful things for people like grind grains, sprouted from seeds indigenous to that ecosystem—with likely the windmill itself made from locally sourced and sustainable materials. But the windmill became an early engine, technologically speaking, of capitalism. Plainly anarchists would put up a quixotic fight in spirited hatred of such wind-powered giants.

There is no way around anarchists' love-hate dilemma that tools and technologies are only as good as the social relations and wisdoms within which they are interwoven. We attempt to craft technologies that are deeply enmeshed in our ethics, put them to autonomous uses as quickly and freely as possible—in hopes of sabotaging or dismantling some of the machinery of social control, but also toward liberatory ways of meeting our collective needs—and are always trying to keep many moves ahead of those who would greenwash, steal, misuse, and abuse our social ecological innovations.

So we scheme and dream, sketch and prototype, hammer and hack, putting in lots of elbow grease, nerdy enthusiasm, and duct tape. The results are technologies such as open-source software and pirate radio, or do-it-ourselves heat sources and water stations for folks who've been unhoused. Maybe soon we'll remember the techne of communally and ecologically constructing homes for people, not profit, from the stuff of the heterogeneous environments in which we live on this planet we call home, like grasses, reeds, limbs, leaves, hay, stones, or mud, and in this way be closer to the everyday changes that compose the cycles of life. Who knows, maybe someday we'll even figure out how to make bicycles wholly out of organic matter without need for the megamachinery of factories or turbomachinery of wind farms.

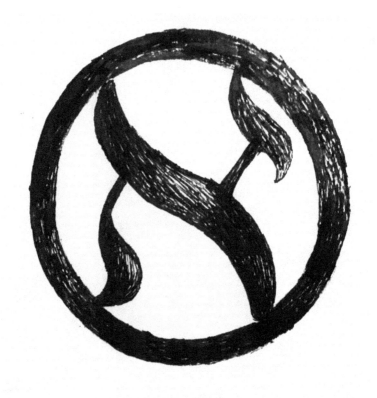

Circle A by Naomi Rose Weintraub

The circle alef design is a symbol for Jewish anarchism—now and throughout history.

Naomi Rose Weintraub (they/them) is a Jewish, genderqueer, anarchist artist and educator based in Maryland on Piscataway land. Naomi's work explores themes of play, imagination, anarchism, and Jewish ritual.

19 | MOST DELICIOUS OF FLAVORS

Anarchism is like an ice cream shop. There are countless flavors to choose from. One can even mix and match, or try out a whole bunch. Yet all of them share the same yummy quality that's identifiable as anarchism and leaves you yearning for more. We all scream for ice cream—and anarchism, no?

Those flavors are often described as the adjectives of anarchism, but that isn't really accurate. Adjectives imply a quality being sprinkled onto the thing itself, like chopped nuts or crushed pretzels tossed atop a few scoops. Each flavor, in contrast, becomes a thing unto itself, such as when chocolate converges with ice cream, making for a wholly new, tastier thing—chocolate ice cream!—that wouldn't be possible without either; the two bring their own richness to the association, complementing but also filling out each other.

So what we have are the nouns of anarchism, versus some boring vanilla version, which historically and contemporarily has never been the dominant flavor. Hence anarchism is like a scrumptious flavor-filled ice cream shop, whether it's a self-managed co-op, a really really free shop, or the short-lived spot opened over a century ago as a fundraiser by the well-known anarchist pals Emma and Alex, two Jewish anarchists.

Which serendipitously brings us round to the circle A flavor here: Jewish anarchism.

This particular blend isn't new. It was one of the original or at least early flavors of anarchism, back when the noun *anarchism* came into vogue. Jewish anarchists were prominent (and oftentimes infamous, especially in the eyes of states and cops) in every aspect of anarchist educating, agitating, and organizing almost from the start, such as our ice cream parlor proprietor-friends above. To offer just one example, Jewish anarchists held down one of the longest-lived anarchist newspapers in the world, the *Freie Arbeiter Stimme* (*Free Voice of Labor*), while also militantly engaging in direct actions.

Jewishness/Judaism, for its part, has had pronounced antiauthoritarian and liberatory sensibilities for millennia, aeons before anyone came up with anarchism as one name for these impulses. As portrayed in our origin story and embodied ever since, we Jews have been willing to wrestle with all authorities, including god, who some might argue is the highest authority. Our centuries-long culture of resistance and resilience is matched by a deeply egalitarian, mutualistic, and ecological ethos, and the duty to continually journey toward freedom while prefiguring "the world to come" in the here and now.

Suffice it to say that we Jews—an incredibly diverse people dispersed far and wide around the globe—have shown repeatedly over thousands of years, in countless diasporic contexts, that it's possible as well as desirable to create and sustain communities without states, in borderless solidarity with Jews and non-Jews alike.

It's no accident, then, that many of us who are Jewish have gravitated toward anarchism, and many anarchists, past and present, are Jews, just as it's no accident that there are Muslim anarchists, Indigenous anarchists, Black anarchists, and Indigenous and Black Jewish anarchists, among others. We've found a home within anarchism because, of course, not all Jewish, Muslim, Indigenous, or Black people are anarchistic, much less anarchists. Yet as peoples with millennia-worth of experience in, say, self-governing communities, nonbinary gender relations, and healing arts, we bring much wisdom to anarchism that it sorely lacks, including how to deeply honor the sacredness of life.

An anarchist ice cream shop can only truly melt our hearts when we decolonize anarchism, recognizing that its flavors are what make it not only edible but delectable too.

Our circle A thus expands here into this circle alef, the first letter in the Yiddish alphabet—a humble letter with no sound of its own, making it a good listener, until it walks side by side with other letters to then say and do a lot together. Alef also represents oneness, as in the oneness implied by the thing called ice cream that can only be made whole through its many distinct flavors.

Circle A by Claudia Ramírez de la Torre (Ryt.Rat)

The beauty of a free society without hierarchy, as represented through nature, which grows by itself, and generates a balanced, blossoming, and lovely landscape.

Claudia Ramírez de la Torre (Ryt.Rat) is a Mexican self-taught illustrator and printmaker. The main subjects of her work involve references from nature, such as wildflowers, plants, and animals. She is also part of a collective for reflection on and diffusion of anarchism called Asedio, acting in Guadalajara, Mexico. Her artistic work has influences from socialist and anarchist ideas.

20 | FROM THE GROUND UP

The grass, they say, is always greener on the other side.

For nonlibertarian revolutionaries or, less kindly put, authoritarian ones, that notion has almost always translated into some version of "things will be 'greener' after the revolution." These types of radicals—as if mimicking the popes and priests who've long kept their own flocks in subservience, utilizing them as god-fearing foot soldiers in colonizing much of the world—claim that the heavenly rewards of revolution will only come on the other side of the barricades, after the leader-idolizing masses overthrow a czar or emperor, and install some version of a "dictatorship of the proletariat."

Suffice it to say, what has happened instead is hell on earth. And millions have perished in the flames.

Anarchists, for our part, are antagonistic to the toll it takes to produce that "greener grass." (Take, as a small example, our advocacy of Food Not Lawns.) We're far more partial to wading into the weeds of the here and now, and from within that thicket figuring out what's already scrappily growing from the ground up. That is, what's already growing that's both detrimental to the structures that mow down all life and yet is beneficial to propagating healthy ecosystems for all. (In the way that dandelions, when they appear with their cheery beauty and medicinal properties, can riotously mess up a sterile, manicured lawn.)

What this ground-up perspective often means in practice is that anarchists act like a trellis, supporting what's already been growing.

Let's say there's a pandemic. From this barren ground, one might think that little can emerge. Not us anarchists!

Sure, like many others, we feel desolate. Yet we also seek out signs of life, usually bursting forth in the most unlikely of places. For there are always far more signs of life than the left-wing authoritarians care to acknowledge, the right-wing authoritarians can put a stop to, and the bystanders in-between can imagine. Anarchists, in contrast, are

drawn toward the wildflowers, all of those self-seeding efforts arising out of necessity, though bringing beauty back to those places that have been abandoned.

Instead of unyielding ground, then, we find cracks in the parched soil. We find what we knew was there all along, dormant until some disaster rains down. We find mutual aid.

After a pandemic is declared, mutual aid projects spring up organically almost overnight. Human animals are, after all, social creatures who need each other to survive. But there's nothing like the state and capital openly abandoning people to remind folks of that fact.

Still, humans in general are kind of rusty at this cooperation stuff, even if at first there's a flowering of it, from little libraries being transformed into little food pantries, to people collecting and dropping off groceries, or circles of folks sewing and gifting protective masks, and the like. This culture teaches competition and "survival of the fittest," not collective care. When there's a virus, this culture says "socially distance," not physically distance *and* socially connect! So here's where anarchists throw ourselves into what's suddenly already growing because catastrophes or no catastrophes, we're continually experimenting with mutual aid models, borrowing freely from each other.

So we join alongside mutual aid efforts, offering all of our already-existing support structures as our contribution—spaces, vision, lessons learned the hard way, resources, networking, and encouragement. Not as leaders or experts or those who want to control, but as fellow human animals who already know that we survive and indeed thrive best when we care directly for each other every single day, come what may.

Circle A by Kelsey Wood

Toward a radical future of food security and land growing with abundance.

Kelsey Wood is a classical and experimental musician, queer activist, and illustrator from Los Angeles, California (Chumash and Tongva land) who currently resides in Madrid, Spain.

21 | FOOD IS LIFE

When it comes to food, anarchists aren't just looking for a seat at the table, or even a seat there at all. We know that there are countless ways and places to find sustenance—all of them outside the seats of power.

So even if some of us don't have green thumbs or can't cook, or aren't adept at running a camp kitchen or handcrafting an outdoor oven, all of us recognize that food is key to the heart of our politics. Food is a basic ingredient in nourishing cultures of existence as well as resistance along with a complementary relation to the earth.

That's because everything that goes into growing, harvesting, preparing, and sharing food, and cleaning up and composting afterward, is for us directly tied to how people could—and in anarchic ways, always have and already do—directly determine and cooperatively supply all that's essential for everybody to thrive. And that's because, relatedly, food is the connective fiber of bringing people together in delicious spaces of their own concocting, whether those places are rebellious or sacred, magical or mundane.

For a community can only truly be and remain autonomous and ecological if it self-governs over its own subsistence. Indeed, the only recipe for freedom over thousands of years that's ever turned out well is when people daily dined, figuratively and literally, on reciprocal relationships to each other and their ecosystems, on dignified and egalitarian lives in common, on the inherent worth of all beings.

So we eagerly throw ourselves into this crucial role of food in everything from riots and outright revolutions, to neighborhood gatherings and grassroots political organizing, to communally supported farms and urban community gardens, to joyous and life-giving as well as life-honoring festivals and rituals, to the humble, everyday excuse to crowd cozily with others into a kitchen in our desire to "feed" ourselves and the processes of life.

Take an uprising after another assassination-by-cops. What some call "looting" during these boiling points—versus the agro-industrial complex looting trillions from lands, workers, and so-called consumers—often involves anarchic folks and anarchists reclaiming basic foodstuffs, the fruits of their labors and the bare minimum long denied them, to then freely redistribute to others on the streets and in their communities. Anarchists are accomplices with those risking much simply in order to do what humans must to survive, which includes eating.

Take the trauma of everyday life under this social order. Anarchists transform food into scrumptious collective care, such as via solidarity apothecaries, which grow, craft, and gift herbal medicine to those in prisons or grappling with state repression. Or by cooking up warm meals as part of mutual aid disaster relief, knowing that "breaking bread" together after a capitalist-catalyzed hurricane is an act not just of nutrition but also healing. Or by leaving jugs of water and cans of beans in the desert borderlands as gestures of hospitality and solidarity for undocumented travelers.

As well, take what it means to intentionally blend friendship and organizing. Anarchists host potlucks in a city-based forest under threat of demolition as a way for folks to get to know each other and the land they will soon join in defending from bulldozers. Or they squat land in opposition to gentrification and turn it into a collective farm that welcomes travelers without papers from numerous countries, and through gardening and eating the produce together it becomes a home for all. Or on the one-year anniversary of a white Christian supremacist murdering eleven Jews in one town, anarchists hold a Shabbat meal as grief space, honoring the dead and affirming the antifascist work that the living are doing.

Take a cornucopia of other beautiful examples, as if reverently unfolding the husks on an ear of corn to then lay our eyes on the brilliant abundance of multicolored kernels, grown from indigenous seed varieties on lands that are commons. Because food for us is always about growing, processing, and sharing life.

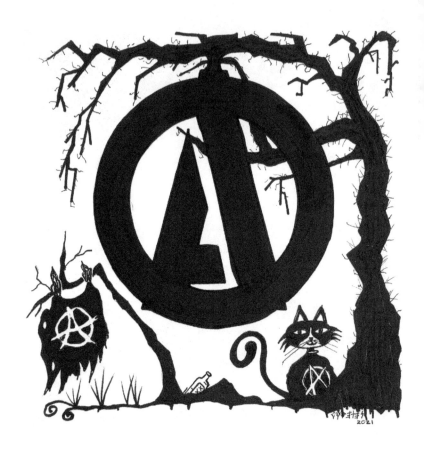

Circle A by Copetes aka Stenciljam

Seeing anarchism through cat eyes, reflecting real freedom, and knowing that animals, nature, and those who respect the earth will always remain alive.

Born in Taxco, Guerrero, and raised in México City, Copetes aka Stenciljam moved to Salt Lake City in the mid-1990s, leaving all of his passions behind: family and friends, music and art. He started to paint stencil graffiti on the walls and streets at an early age. Copetes never knew what graffiti really meant to him as an artistic expression, but just did it for fun and to escape from the crude reality of living as a punk rocker in a judgmental society. In his work, he represents the voices of oppressed people of all ages who struggle every day to obtain dignity and respect.

22 | DANGEROUS TOGETHER

Anarchism can, at times, look scary and feel dangerous.

Take the black bloc tactic. Here a group of people dress from head to toe in anonymizing all-black attire. When done well, it creates a wedge of collective solidarity against state repression during an action. The cops can't pick out individuals, and thus pin certain mischievous behaviors and draconian charges on them. If arrests are made, everything from withholding all detainees' names as part of our jail solidarity to, later, engaging in collective legal defense is made immensely more doable—and winnable.

Yet for years the masked-up faces in a black bloc struck fear not necessarily in the cold-hearted injustice system but rather in the hearts and minds of many people who should be on our side. Such people rarely made the connection between the friendly anarchists doing collective childcare or mutual aid snow shoveling, and the "scary" ones at a demo setting dumpsters on fire. (Never mind that the trash bins served as community self-defense roadblocks shielding all protesters from the police—a friendly anarchist gesture if there ever was one!)

Fast-forward to a global pandemic and summer of uprising. Suddenly, millions of people—fearful of COVID and now disillusioned with cops—took to masking up. For a while nearly everyone looked like an anarchist! Masks became associated with exactly what anarchists had used them for all along: collective care. Moreover, anyone *without* a mask became seriously scary and deadly dangerous, especially because of lot of them were fascists.

Like with many things anarchistic, then, there's a generative tension here.

At times we truly do need to make certain people, such as racists, and certain systems, such as colonialism, feel afraid—and again and again—as we struggle toward abolition. Yet this frequently doesn't entail doing anything remotely scary, and usually quite the opposite. The warmest

and fuzziest of mutual aid networks across regions or self-governing autonomous communities, for instance, are dangerous threats to nation-states. Our self-determined infrastructures, by their very egalitarian presences, reveal that cultures of life are indeed possible against and beyond their death cults.

At other times, though, we both want to welcome people into our spaces and scare away those who might harm us. Since the line between the two will always be blurry, it's our continuing willingness to rethink our protocols and practices of care that make the difference. Take punk or other rebellious music, intended to rage against the machine by countering it with do-it-ourselves social relations, plus lots of music, zines, and dancing. But it can prove tricky to make a house show feel inviting to friends and anarchist-curious newbies yet inhospitable to misogynistic or transphobic behaviors. So we experiment, even if always imperfectly, with imaginative ways to remain a threat to the dominant culture while also creating safer, braver, and less dangerous places for anarchistic folks striving to queer culture together.

At our best, we're "careful with each other so we can be dangerous together," as the saying goes, whether on the streets against white Christian supremacists or in a squat against capitalism. Speaking of which, perhaps there's no better, or sillier, example of this than a now-annual "porch of doom" gleefully constructed outside a longtime squat-like collective house in a neighborhood that's been home to generations of anarchists. Each year a scary theme is picked—like climate catastrophe and displacement—and then a haunted DIY labyrinth is constructed around it. On Halloween, thousands of kids line up for their turn at wandering through this sociopolitically dangerous maze while being "frightened" by friendly anarchistic folks in costumes who'll treat them to candy at the end.

See, we're not so scary after all—at least never toward people from all walks of life who are similarly seeking the sweetness of freedom and dignity.

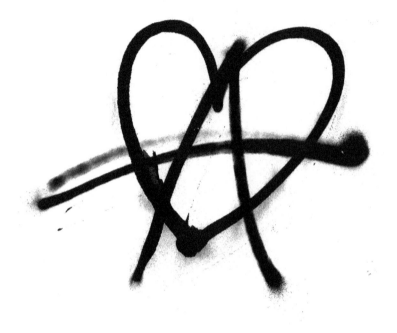

Circle A by Kevin Yuen Kit Lo

Anarchism, like love, is an action, thrown up against the wall, again and again.

Kevin Yuen Kit Lo is a graphic designer, educator, and community organizer based in Montréal/Tiohti:àke. He is the creative director of LOKI, a design studio working at the intersections of graphic design, cultural production, and radical social change.

23 | LOVE IS FREEING

Anarchists are especially enamored with four-letter words. Take *ACAB* or *fuck* the police and endless variations on that theme, such as *fuck* patriarchy. So enraptured are anarchists with such four-letter terms of acrimony that these words are recognizable around the globe, whether spray painted on walls or put into abolitionist practice. Indeed, *ACAB* has put Esperanto and its aspirations to shame in becoming a universal language within and well beyond anarchism.

Yet one four-letter word has taken longer to fully enter the anarchist vocabulary: *love*.

Sure, this term was coupled well over a century ago with another four-letter word, and one that has always been near and dear to anarchists, *free*, making for the union of *free love*. But free love in theory and especially practice became narrowed down to a three-letter word, *sex*. As pleasurable and consensual as sex can or ought to be, one can have lots of it without any love. And when sex isn't pleasurable and/or consensual, it can have diminishing returns on love or be downright unloving, as many an anarcha/x-feminist knows all too well.

One can have an orgasmic plenitude of love, however, if expressions of *love* wrap their arms around so much more than just sex.

As such, slowly over the decades anarchism began to see the potential of encircling itself with love. It's commonplace to now see this four-letter word bandied about in everything from "love and rage" to "hate fascism, love soccer" to "fall in love, not in line." Still, such proclamations frequently remain just that, and it's only been because of the exhausting rage and exhaustive efforts of feminist, queer, and/or trans anarchists that anarchism, in praxis, has fallen deeply in love with *love*.

Of course, the relationship of anarchism to love is a work in progress, as it always will and probably should be. Love takes labor. Indeed, one of its best attributes is that it points beyond capitalism. It demands of us that we're at once antiwork—since work under capital is always

an abusive relationship, devoid of love, no matter how much we delude ourselves otherwise—and ardent proponents of the labors of love—the passion-filled ways we produce and reproduce what we need and desire, materially and immaterially.

Love also is one of the few, if only, "things" that capitalism can't completely commodify. Sure, this society of the spectacle can hawk the notion that "chocolate and roses" is the battle cry of love. The elusive quality of love, though—still indescribable, despite countless poems and songs singing its praises; still unable to be bottled, despite countless potions—has made it impervious to the arrows of capitalism. What we feel when we love and are loved is at heart an ungovernable emotion that allows us to embrace what it just might feel like to be free.

Then too, it allows us to enter into postscarcity anarchism in a way nothing else can. For love, when expanded to circle all of our relations with humans and the nonhuman world, has the capacity for endless abundance. Love only grows when we share it. The more we open ourselves to love, the more we circulate our love as a verb, the more there is for everyone, and the more there will be enough to make us feel wholly loved when our hearts are broken.

Such a wealth of love points beyond property relations, toward commons; beyond stinginess, toward gifting; beyond going "hungry," toward nourishment; beyond competition, toward cooperation; beyond binaries, toward boundless possibilities—beyond all the ways we're compelled to beg for crumbs when in fact there's deliciousness aplenty for us all.

Love, in short, isn't free; far better, love is freeing. Love is the key to freedom.

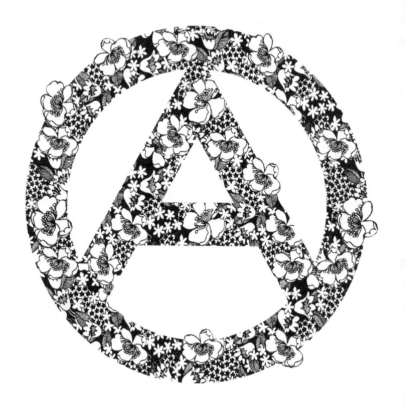

Circle A by Landon Sheely

Anarchism offers hope.

Landon Sheely is a classically untrained and foolishly optimistic propagandist.

24 | BEAUTIFULLY SIMPLE

Anarchism is simply beautiful.

It is beautiful, mundanely, in a quiet way. It just *is*, and always has been, and likely always will be, whether our specific species is here anymore or not. Because beyond a mere politics or label, anarchism embodies a tendency in nature, of which we human creatures are a part.

So even if we forgot to notice the sociability of trees communicating through their roots to nourish and protect each other, or the sociability of ducks and geese congenially sharing a common home along a river, or the sociability of flower varieties dancing joyfully together in a light spring breeze as the sun warms their faces, there is cooperation all around us.

Life simply wouldn't be possible without it. That, in itself, is a simply beautiful notion.

This quiet beauty is so remarkable, though, that it can't help but enchantingly bubble over.

So even if you're absentmindedly strolling past a hive organically built by its communal inhabitants in a location of their own choosing, it's hard not to take in hints of the honey-sweet fragrance of sociality busy at play, which then leads your nose to hints of the nearby scents of cooperating blossoms, which amicably lend nectar to the bees, who genially lend pollen to the flowers.

From there your nostrils might become more attuned to such subtle whiffs of everyday anarchism, and you'll pause more and more often to breathe in the pleasant smell of sociality, so routine that you'd long ago learned not to take note.

Whereas before you hurried by the community garden, rushing from one compulsory busyness to another dreary obligation with nary a glance, now you'll stop at the artful patchwork of a fence constructed on a collective workday by many hands—and meant to keep critters out yet welcome gardeners in—and swing open the gate. Your lungs will fill

with the perfume of tomato plants, but also the communal compost pile, and the way that the patchwork quilt of plots can't help but encourage sociable sharing, whether of weeding or tools, seeds or harvests.

Later you'll meander past what used to be bland wall on the side of a building, and teens will be gleefully and perhaps messily transforming their collective sketch, penned in various handwritings on a huge piece of paper now spread out on the ground, into a colorful mural, cooperatively dreamed up over hours of brainstorming, laughter, and sometimes getting happily distracted and goofing off together.

And if it happens, weather-wise, to be a perfect day or delightful evening, your feet will steer you toward a park, and even if there might be signs of "No this" and "No that" sprinkled here and there, sheer anarchy will have busted out, because how could it not when you get so many people together in one big, beautiful space? We, too, are social beings, like the trees, the birds and the bees, and flowers. Over here musicians are jamming as ever-more folks join in; over there is a pickup soccer game among people who were formerly strangers; in another spot, there's a birthday party, with passersby continually offering their good wishes and in turn being offered a slice of cake; nearby, in their parts of the park, off-leash dogs happily socialize, kids turn playground equipment into a giant game of tag, and skateboarders teach each other various tricks.

These and so many other forms of agreeable cooperation—from clothing swaps to filling up community spaces with everything for everyone when the power grid and the powers that be fail right after a disastrous tornado—aren't anarchism per se. They are instead what show us that anarchistic interrelations are routinely, freely, always already here, streaming over their bounds to sociably draw us in. They are not just simply beautiful; they are simple to do, beautifully and daily.

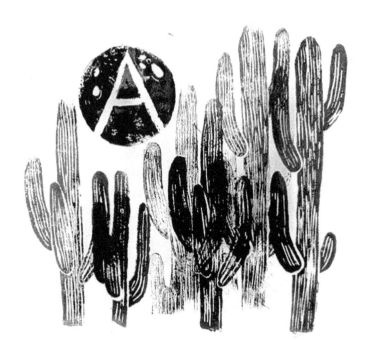

Circle A by muqu

El mundo donde quepan muchos mundos esta aqui, en nosotros / The world where many worlds fit is here, in us.

Muqu is an anarchist with roots in the south. They hate borders and love birds.

EPILOGUE:
THE BEAUTY OF OUR CIRCLE

To aspire to live in an anarchistic world means continually journeying toward the horizon. It will also never be easy. There is no going from point B to point A(narchism); there's no linear or smooth route, much less a map. It means forever running up against thorny obstacles along the way. And if one doesn't take good care with each footstep, intentionally picking out solid ground or being willing to shift direction, it means frequently getting stuck on various prickly challenges, and for too many people, then giving up and turning back.

What makes all the difference is noticing the beauty as one traverses to and fro. For it is always there too.

That beauty, as should be clear now that you've reached this epilogue, doesn't exist separately from what stabs us in the heart daily. To be an anarchist for the long haul means proceeding along the path knowing that we'll face risks and dangers. But if all we ever see, if all we ever imagine and share with others, is what we don't like and don't want, what we despise and oppose, we'll rarely convince anyone to stroll bravely with us. And ultimately we'll become too dispirited ourselves to want to venture toward freedom either.

It is the beauty of anarchism that aids us in staying the course for life, as self-taught cartographers of myriad dreamscapes, and bringing more and more friends, neighbors, and other accomplices along with us.

Anarchism must be like the face of a full moon, beaming mischievously and yet comfortingly, winking with possibilities, offering the biggest and brightest of compasses. It must always be present, urging people to set their sights upward and onward, sometimes in wholly visible ways, sometimes at half strength yet still powerful enough to move water, and sometimes as the merest sliver of potentiality.

The end of this book, then, is really only a beginning. For while there is no end to the journey toward anarchistic social organization and social relations—not to mention ecological ones—there is no end to the beauty of our circle, which itself can be forever widened and reenvisioned.

So pick up a pen or pencil, felt tip marker, can of spray paint, or whatever medium or practice strikes your anarchic fancy, and set out on your own prefigurative pathways to illustrate the beauty of anarchism and/as life.

ABOUT THE AUTHOR

Cindy Barukh Milstein is a diasporic queer Jewish anarchist who adores nothing better than shaping and sharing magical do-it-ourselves time-spaces with others, especially face-to-face. This has included, to mention a few, anarchist salons and pop-up social centers, study groups and anarchist summer schools, and mourning circles; Coffee Not Cops and other public gatherings, festivals, and interventions; Station 40 in San Francisco and Black Sheep Books in Vermont; and the Institute for Anarchist Studies, Renewing the Anarchist Tradition conference, and Montreal Anarchist Bookfair. They've long been engaged in anarchist organizing and collectives, such as SF and Detroit Eviction Defense, Defend J20 Resistance, and Huron Valley Solidarity and Defense, as well as social movements, including the alter-globalization movement, Occupy Philly, Montreal student/social strike, and "fuck the police" uprisings.

Milstein is never at home in this world, so is always trying to make new ones, or at least mend this one. Meaning they tend to think and dream big, weave connections among people and projects, and make community (without states) in many places. They're fond of bringing books to life, and are always honored to do grief care for deaths and other losses. Their greatest aspiration is to live up to the ethics of anarchism, especially by practicing as much solidarity, collective care, and love as possible.

You can find them on Instagram @cindymilstein and via their blog, cbmilstein.wordpress.com. They would be delighted to hear from you and/or be invited to come visit and hang out, do a talk, and/or facilitate dialogues that wrestle with the messy beauty of this world.

If you liked this book, see Milstein's previous titles, all labors of love:

Anarchism and Its Aspirations, by Cindy Milstein (AK Press, 2010)

Paths toward Utopia: Graphic Explorations of Everyday Anarchism, by Cindy Milstein and Erik Ruin (PM Press, 2012)

Taking Sides: Revolutionary Solidarity and the Poverty of Liberalism, edited by Cindy Milstein (AK Press, 2015)

Rebellious Mourning: The Collective Work of Grief, edited by Cindy Milstein (AK Press, 2017)

Deciding for Ourselves: The Promise of Direct Democracy, edited by Cindy Milstein (AK Press, 2020)

There Is Nothing So Whole as a Broken Heart: Mending the World as Jewish Anarchists, edited by Cindy Milstein (AK Press, 2021)

STRANGERS IN A TANGLED WILDERNESS

Strangers in a Tangled Wilderness is a media publishing collective dedicated to producing and curating inclusive and intersectional culture that is informed by anarchistic ideals. We aim to be inclusive in that we want to reach people who have not previously felt welcomed by existing subcultural and countercultural media. We intend to be intersectional in that our politics are not limited to individual issues. We are informed by anarchistic ideals, which is to say that we each, under various labels and coming from various backgrounds, desire a world without coercive hierarchies such as patriarchy, colonialism, capitalism, or state control. We make no claim about the individual politics of our individual contributors, of course, but these are the principles that guide us in selecting work.

There is a place for political theory, and we might publish some of it from time to time, but that's not what we're about. Since 2003, Strangers in a Tangled Wilderness has published fiction, comics, poetry, memoir, pop culture analysis, and history. We're as liable to publish cookbooks, plays, or how-to guides as we are to publish theory or analysis of current events.

We're not looking to gatekeep; we're looking for content that blows the gates off their hinges and makes more people from more walks of life with more interests feel welcome. We're looking for content that doesn't know where else it fits in, for people who don't know where else they fit in.

For more on Strangers in a Tangled Wilderness, see our website at www.tangledwilderness.org/.

Printed in the USA
CPSIA information can be obtained
at www.ICGtesting.com
BVHW042007300723
667991BV00005B/22